WORDS & PICTURES

WORDS & PICTURES

Writers, Artists
and a Peculiarly British Tradition

Jenny Uglow

faber and faber

First published in 2008
by Faber and Faber Limited
3 Queen Square London WC1N 3AU

Typeset in Bulmer by Faber and Faber Limited
Printed in England by MPG Books Ltd, Bodmin, Cornwall

A CIP record for this book
is available from the British Library

ISBN 978-0-571-24250-4

2 4 6 8 10 9 7 5 3 1

For Matilda

Contents

'It hath been thought a vast Commendation of a Painter, to say that his Figures *seem to breathe*; but surely, it is a much greater and nobler Applause, *that they appear to think.*'

Henry Fielding, *Joseph Andrews*

'And what is the use of a book,' thought Alice, 'without pictures or conversations?'

Lewis Carroll, *Alice's Adventures in Wonderland*

Foreword

Double Vision

Books are often put into our hands before we can read, but we pretend we can, copying the way grown-ups look steadily at the page, and 'reading' the pictures. But this is a different kind of reading. A picture gives us all the information at once, which should mean that we grasp the content faster. But this isn't quite true. A picture captures a moment and holds it: its perpetual present is at odds with the flow of narrative or orderly description. We see the whole but then look at the parts, putting them together in a different way. When children pore over a scene, they spot new details and ask new questions. What is the giant wearing? Who is that behind him on the stairs? Where does that gate lead to?

Who knows which came first – the forming of sounds into languages, with their infinite range of meaning, allusion, rhythm and stress, or the mazes traced on the soil, the statues and idols, the animals on cave walls? Later, words and images came together in ideographs, the picture shorthand of items on merchants' trading books, military instructions, the attributes of deities and kings. Later still, these formed the

alphabets of written cultures. And when people sat around a storyteller or listened to ballads, surely the words conjured pictures, of seas and boats, battles and blood. The singer of a ballad like 'The Twa Sisters of Binnorie', for example – found in different versions across Northern Europe – wants us to see, as well as to hear, the moment when the dead woman unmasks her foe:

> Then by there came a harper fine
> Such as harp to nobles when they dine.
> He's ta'en three strands of her yellow hair
> And with them strung his harp so rare.
>
> He's gone him to her father's hall
> And played the harp before them all.
> O, then the harp began to sing,
> And it's 'farewell, sweetheart', sang the string.
>
> And syne the harp spake loud and clear,
> 'Farewell my father and mother dear!'
> And then as plain as plain could be:
> 'There sits my sister who drowned me.'

The song points a finger, asks the whole court to turn and stare. But if words convey pictures, the opposite is also true. We need language to decipher what we see. Go round an art gallery, look at grand 'history paintings', and try to work out what is going on in the pictures without looking at the labels. Once you read the description, the content may become clear,

but only if you know the myth, the battle, the royal marriage that the artist is depicting. And content is only one aspect of visual art – just as illustration is only one of many complex relationships between artists and writers, images and words.

Illustration, however, is where I begin and end this book. The oldest illustrated texts in the West, from as early as 1370 BC, are copies of the Egyptian Book of the Dead, buried with the deceased so that the spells and rituals could help the soul's path. But scrolls from around the same time also show satirical and ribald drawings – anger and desire prompted pictures just as readily as faith and death. Pictures could pronounce power, like the portraits of emperors adorning coins across the Roman empire. And surviving early manuscripts bear witness, too, to their vital role in identification, like the sixth-century copy of Dioscorides' herbal, now in Vienna, which has drawings of herbs and plants, and even coral rising from the sea. Pictures and diagrams have remained an essential accompaniment to technical description: in the words of Leonardo da Vinci, 'The more minutely you describe the more you will confine the mind of the reader, and the more you will keep him from the thing described. And so it is necessary to draw and to describe.'

Images accompanied early biblical texts across Christendom, from the jewelled Byzantine manuscripts to the Lindisfarne Gospels and the Book of Kells, where pagan Celtic patterns swirl around sacred words. Such adornment could be a testament of faith, an act of glorification, or a simple

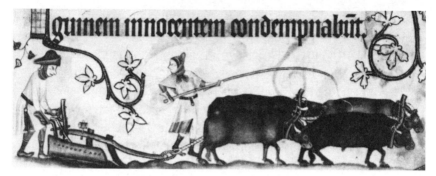

teaching device. The fourteenth-century Holkham Bible
Picture-Book in the British Library was commissioned by a
Dominican friar, probably for the travelling friars to show
people as they preached, and its illustrations are dramatic and
lively – a book designed for a purpose (experts also suggest
that this manuscript may have served, among other things,
as a pattern book for embroidery). Artists embellished manu-
scripts in such detail, often at a complete tangent to the text,
that we often turn to them for pictures of contemporary life and
seasonal activities, like the oxen ploughing in the fourteenth-
century Luttrell Psalter above. With the arrival of printing,
woodblocks could be set into the page as it was printed,
reaching their height in the designs of Holbein and Dürer in
Northern Europe, and in the elaborate Renaissance engravings
of Italy. By the end of the sixteenth century, however, these
were largely replaced by copper-engravings, which allowed for
much finer work. Two centuries later, steel engraving and

lithography arrived, and soon other new technologies would replace these in their turn. The medium is always changing.

The roads stretch through time from illuminated manuscripts to graphic novels and comic strips, from medieval frescoes to photographs, from herbals and bestiaries to newspapers and banknotes, movies and digital images. There are constant surprises. We meet artists we might not expect to find in the realm of book illustration: Botticelli, Rubens, Poussin, Rembrandt, Turner and Delacroix. In the small patch of British literature alone, avenues stretch out and intersect. One could follow Shakespearean scenes, from Hogarth's *Falstaff Examining His Recruits*, to the Boydell Shakespeare Gallery and Millais's *Ophelia*; or examine the literary paintings of the Pre-Raphaelites, and the works of Rossetti and Morris; or question the 'Englishness' of twentieth-century artists and engravers like Paul Nash, John Piper, Gwen Raverat or Eric Ravilious. Or one could toss 'high art' aside to look at the pictures in 'Penny Dreadfuls' and Victorian magazines, or cartoons from Rowlandson and Gillray to Martin Rowson and Steve Bell. Or, or . . .

Artists and cartoonists, good and bad, can alter our perceptions. Some illustrators respond so strongly that they create a new, parallel work, like Mervyn Peake's haunting *The Rime of the Ancient Mariner*. And an artist can literally rip up a book and make it his own, as Tom Phillips did when he found an old copy of a Victorian novel, W. H. Mallock's *A Human Document*, and began blocking out passages, leaving odd sen-

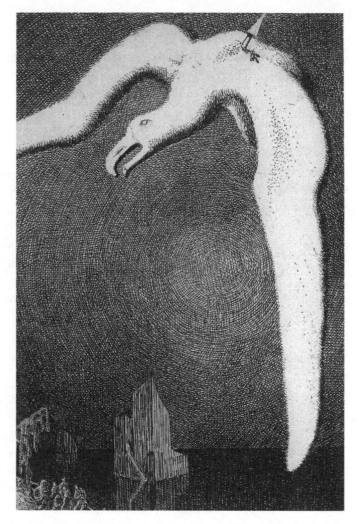

Mervyn Peake, 'The Albatross', *The Rime of the Ancient Mariner*, 1943

tences or words and surrounding them with ink, watercolour and collage. This became *A Humument*, printed as a separate work in 1970, yet endlessly revisited, evolving until that edition itself will eventually be replaced.

I cannot help putting my thoughts into words and pictures simultaneously: reading, dreaming, writing, imply vision, in all senses. I find abstract argument hard, because I cannot *see* it. Yet words alone convey vivid sense-impressions to people without sight – space, texture, smell, sound – so what, in that sense, is a 'picture' in words? Stephen Dedalus asks this in *Ulysses*, as he walks the beach, pondering the 'ineluctable modality of the visible', the way the sighted think through their eyes:

Signatures of all things I am here to read, seaspawn and seawrack, the nearing tide, that rusty boot. Snotgreen, bluesilver, rust: coloured signs . . . Shut your eyes and see.

Stephen closed his eyes to hear his boots crush crackling wrack and shells. You are walking through it howsomever. I am, a stride at a time. A very short space of time through very short times of space. Five, six: the nacheinander. Exactly: and that is the ineluctable modality of the audible. Open your eyes. No. Jesus! If I fell over a cliff that beetles o'er his base, fell through the nebeneinander ineluctably. I am getting on nicely in the dark. My ash sword hangs at my side. Tap with it: they do . . . Am I walking into eternity along Sandymount strand? Crush, crack, crick, crick.

7

The territory of word signs, sight signs, sound signs is a great, rich landscape with cloudy theoretical distances. I am just straying across the border. But my excursions feel like adventures. They have opened new subjects to me, and made me think of ones I am familiar with, like Hogarth and Bewick, in an entirely new light.

This short book looks at different kinds of connections between artists and writers in the eighteenth and nineteenth centuries. It begins with artists responding to a text, comparing the early illustrations to Milton's *Paradise Lost* and Bunyan's *The Pilgrim's Progress*, almost contemporaneous yet profoundly different in form and address. In the case of Hogarth and Fielding, artist and writer work side by side, borrowing words from the other's craft to define their innovative ventures – the novelist compares himself to 'a comic History-Painter', the artist calls himself a dramatist. Such stealing of terms is common. So what did Wordsworth mean when he called the wood-engraver Thomas Bewick 'The Poet of the Tyne'? Here writer and artist seem poles apart, yet prove closer than we think (and than Wordsworth imagined).

Finally, the book circles back to a fourth kind of connection, when writer and artist work together from the start, and hints at the tensions beneath 'perfect' collaborations. The topics are all different, yet they overlap. They suggest a dynamic between 'high' and 'low' art, authority and irreverence, which does, I think, create a peculiarly British tradition, a popular art that makes its own rules.

Milton, Bunyan and the Artists
Epic and Chapbook

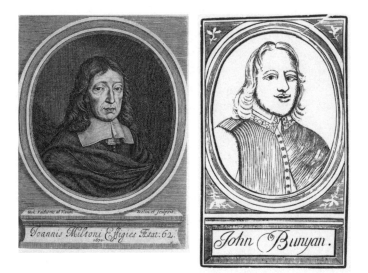

Two frontispieces – the Latinate copperplate of *Joannis Miltoni*, engraved by William Faithorne for the *History of Britain* in 1670, and the rough woodcut of plain *John Bunyan* – tell us almost all we need to know. If there was a class structure in literature in late seventeenth-century Britain, Milton was at the top and Bunyan at the bottom. Both have the same simple garb and straggly hair, but we can see straight away that they write in contrasting modes, for quite separate audiences.

Although they were published roughly ten years apart – *Paradise Lost* in 1667 and *The Pilgrim's Progress* in 1678 – these two great works of the English religious imagination, so totally different, both belong to the 1660s. Milton was then in his late fifties. Educated at St Paul's School and Cambridge, he was admired as a poet on the Continent, but in Britain his fame, or notoriety, rested chiefly on his polemical prose and his work for Cromwell. At the Restoration he was in hiding in London: his books were burned and he was later arrested and imprisoned. By now he was also completely blind, yet his narrator sings on 'with mortal voice',

> unchanged
> To hoarse or mute, though fall'n on evil dayes,
> On evil dayes though fall'n, and evil tongues;
> In darkness, and with dangers compast round,
> And solitude.

When Milton dictated these lines, John Bunyan was also suffering. A tinker's son from yeoman stock, and briefly a conscript in Cromwell's New Model Army, Bunyan was a wild youth by his own account, who underwent a painful conversion and, after years of doubt and anxiety, became the leader of the Baptist congregation in Bedford. In 1660, aged thirty-two, Bunyan was arrested under an old Act against sectarian preaching and lingered in gaol for twelve years because he refused to promise not to preach. His spiritual autobiography, *Grace Abounding*, appeared in 1666, and it is generally agreed that he wrote most of the first part of *The Pilgrim's Progress* before his release in 1672, finishing it during a second spell in prison in 1677.

Both works are intensely visual as well as visionary – Milton painting the soaring visions of hell, heaven and Eden in his blindness, Bunyan imagining Christian's hard journey to the Celestial City in his dark prison cell. In Victorian days these books would sit side by side on the family bookshelf as revered classics but the early illustrations show that they followed quite different paths before they reached that point. In both cases the images speak their own pictorial language, expressing their inheritance and creating a distinctive lineage. The visual tradi-

tions echo the verbal: while Milton looks back to Virgil, blending images from Ovid and classical mythology with biblical narrative, the forebears of Bunyan's allegory are the medieval visions of Piers Plowman, sermon exempla, emblems and folk tales.

Editions of Milton's work were often funded by wealthy subscribers, while Bunyan sold for shillings in the bookshops and pence in the pedlars' packs. The fine Milton volumes appeared in large folio or quarto size (the printers' large sheet folded in four) while Bunyan was published in octavo (folded in eight) and the cheaper editions in duodecimo (folded in twelve). Several critics have studied illustrations of Milton's work, and I follow their lead gratefully, but virtually nothing has been written on Bunyan, except in relation to Blake. This in itself reflects the critical value we place on different genres and forms of publishing.

Paradise Lost sold slowly in the years before Milton's death in 1674. Its wider reputation, it is said, stemmed from the third edition of 1688, published by Jacob Tonson and Richard Bentley. Tonson had established his business in Chancery Lane ten years earlier with the specific aim of publishing illustrated editions of major English writers. He snapped up the copyright of *Paradise Lost* when no one else seemed interested, and his illustrated folio edition was impeccably timed, appearing in the year of the Glorious Revolution, his patrons and subscribers including several influential Whigs. The production of the volume announced the importance of this

'English epic'. There were twelve designs, one for each book, several by the Brussels-born artist John Baptist de Medina, three signed by Henry Aldrich and one by Bernard Lens; most were engraved by Michael Burgesse.

All the artists turned for inspiration to existing biblical illustrations or classical scenes, even for the early books, which are all Milton's invention. Thus the illustration for Book I (which set the style of Roman military garb for Satan), shows him defiant:

> on the Beach
> Of that inflam'd Sea, he stood and call'd
> His Legions, Angel Forms, who lay intrans't
> Thick as Autumnal Leaves that strow the Brooks
> In Vallombrosa, where th'Etrurian shades
> High overarch't imbowr.

The artist may have noted Milton's beautiful, classical-rural image – his Satan does indeed look as if he is sweeping up leaves – but if he also appears to be rowing, or punting, this is no surprise. As the critic Mary Ravenhall pointed out, the figure of Satan challenging his troops – 'Awake, arise, or be for ever fall'n' – is actually based on a 1560 engraving by van Heemskerck of Charon rowing souls across the Styx. Similarly, Aldrich's illustration of the expulsion from Eden in Book XII was based on Raphael's adaptation of a Masaccio fresco, showing Adam and Eve full of despair, whereas Milton's Raphael consoles them with the promise of redemption and bliss in Paradise. They leave with a promise of hope:

'Satan rousing his legions', *Paradise Lost*, 1688

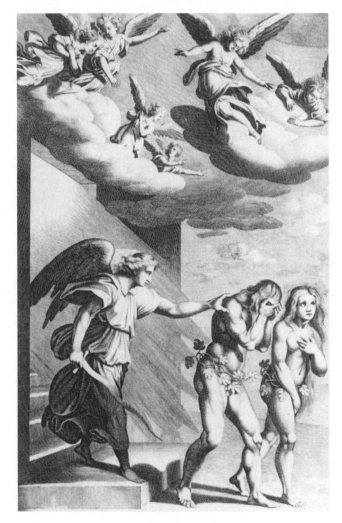

'The expulsion from Eden', 1688

Some natural tears they drop'd, but wip'd them soon;
The World was all before them, where to choose
Thir place of rest, and Providence thir guide:
They hand in hand with wandering steps and slow
Through Eden took thir solitarie way.

Any misreadings by the artists went unnoticed. It was a fine production, worthy of a national muse. Tonson had cornered the Milton market and just before he retired he planned another lavish edition. The two new volumes of Milton's *Poetical Works* were published by his nephew, Jacob II, in 1720, in a fine folio format. The first volume contained *Paradise Lost*, decorated with energetic but heavy baroque designs by Louis Cheron and Sir James Thornhill, engraved by Gerard van der Gucht, which scrolled across the opening to each book like classical bas-reliefs. Cheron had been invited to produce designs for St Paul's, while Thornhill had decorated the great ceiling at the Royal Naval Hospital, Greenwich. Their Milton was undeniably impressive, but it lacked warmth, except in a charming vignette of the blind poet instructing his angelic muse:

Of Man's First Disobedience, and the Fruit
Of that Forbidden Tree, whose mortal tast
Brought Death into the World, and all our woe,
With loss of Eden, till one greater Man
Restore us, and regain the blissful Seat
Sing Heav'nly Muse . . .

Thirty years later, the next illustrator changed the tone radically. In 1749 Jacob Tonson III gave the commission to Francis Hayman, a fine portraitist and close friend of William Hogarth, who had begun as a theatrical scene painter and had provided many of the lively scenes that decorated the supper boxes at the Vauxhall Pleasure Gardens. His rococo, theatrical designs, engraved by Grignion and Ravenet (the French engravers of Hogarth's *Marriage à la Mode* seven years earlier), brought the protagonists into the foreground. Hayman's rebel angels still had a baroque, even mannerist grandeur, but his Satan was now less of a demon than a tragic figure, whose angelic strength and beauty, as Milton described, are spoiled by rage, envy, malice and despair. By contrast, Hayman's Adam and Eve inhabit a domestic, pastoral Eden. With their dog at their feet – and the lion and the lamb and the unicorn playing happily in the corner – they could be frolicking naked in a country park.

One unusual drawing in the British Museum treats *The Pilgrim's Progress* in a similarly rococo style – a sketch for a frontispiece by William Kent, showing Christian toiling uphill towards a Celestial City that looks like Burlington House embellished with Italianate towers. Kent, with his Catholic friends, his passion for Italy, Palladian architecture and classical themes, seems an unlikely Bunyan reader, but he drew many illustrations for books, including Spenser's *The Faerie Queene*, Pope's *Odyssey* and Gay's *Fables* and *Poems*, and often worked for Jacob Tonson and his rival Bernard Lintot, so perhaps this

Francis Hayman, 'Satan spying on Adam and Eve',
engraved by Charles Grignion, 1749

was a plan for a fine Bunyan edition that was never realised.

The sketch remains an oddity because the illustrative history of *The Pilgrim's Progress* took a different route altogether. Milton's epic is, in a supreme manner, external, supranatural, telling the great myth of the war in heaven, the Creation, the Fall of Man and the promise of redemption by the Son. At it unrolls in thrilling, sonorous verse, the narrator himself is our interpreter, singing through his muse. Bunyan's dreamer, by contrast, merely presents the riddle, the allegory that we must interpret, and he – like Christian – is often puzzled, entering the story to ask questions (and allowing Bunyan even more freedom to 'interpret' for our benefit).

The Pilgrim's Progress was an instant success when Nathaniel Ponder – known ever after as 'Bunyan Ponder' – published it from his shop near Cornhill in 1678. Written in down-to-earth, often comic prose, as opposed to Milton's 'difficult' poetry (though many of Milton's lines have a simple eloquence), it was reprinted almost immediately, and sold over a hundred thousand copies before *Paradise Lost* reached four thousand. The first edition had no illustrations, but in the following year, for the third edition, Ponder included the famous portrait frontispiece, engraved by Robert White, illustrating Bunyan's evocative, alliterative opening:

> As I walk'd through the wilderness of this world, I lighted on a certain place, where there was a Denn; And I laid me down in the place to sleep: And as I slept I dreamed a

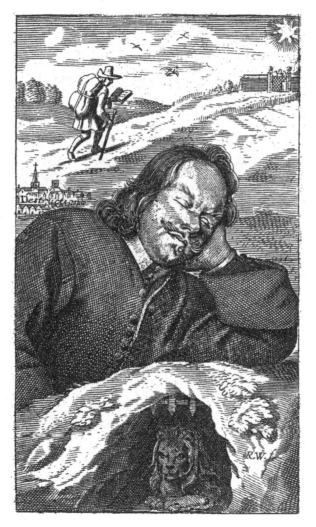

Robert White, frontispiece to *The Pilgrim's Progress*, 1679

Dream. I dreamed, and behold I saw a man cloathed with Raggs, standing in a certain place with his face from his own House, a Book in his hand, and a great burden upon his back. I looked, and saw him open the Book, and Read therein, and as he Read, he wept and trembled, and not being able longer to contain, he brake out in a lamentable cry; saying, *what shall I do?*

White's illustration is a brilliant, understated imagining of the process of dreaming, even to the wrinkle between the sleeper's eyebrows, as the imagination floats between visions above and terrors below, where the lion looks out from his cave.

Although *The Pilgrim's Progress* is a quest for assurance of salvation, its tone is not supernatural but of the earth, earthly. Christian is fallen man, and although told that he is one of the elect, he still faces terrors: he has to *know* his state of grace internally. The allegory mirrors the trials, agonies and bursts of hope that Bunyan himself had described in *Grace Abounding*. The stories, places, people Christian meets, represent states of mind that he must pass through before he can reach his goal. The road winds uphill all the way.

In the second or third edition another illustration appeared, in a very different style to the frontispiece, a woodcut of 'The Burning of Faithful'. Perhaps this crude cut was Ponder's attempt to 'place' Bunyan and boost sales by adding a picture strongly resembling the illustrations in an earlier Protestant bestseller, *Foxe's Book of Martyrs* of 1563. Ponder, however, wanted to

'The Burning of Faithful', c.1679

appeal to a 'higher', literary market. The advertisement to one printing of the fifth edition in 1680 (there seem to be two fifth editions, one with and one without pictures) announced that 'The Pilgrim's Progress having found good Acceptation among the People . . . And the Publisher observing that many persons desired to have it illustrated with Pictures, hath endeavoured to gratifie them therein: And besides those that are ordinarily print-ed . . . hath provided Thirteen Copper Cuts'. Bunyan added a quatrain to go with each cut, explaining the scene or offering a moral. For Faithful's martyrdom, for example, he wrote:

Brave *Faithful*, Bravely done in Word and Deed!
Judge, Witnesses, and Jury, have instead
Of overcoming thee, but shewn their Rage,
When thou are dead, thoul't live from Age to Age.

Later editions printed these copperplates interleaved in appropriate places in the book, but to begin with they were sold separately, unbound, at a shilling per set. With Bunyan's verses they made sense as a visual progress on their own (an intriguing forerunner of Hogarth).

The engravings also reflected the different visual and literary traditions that underpinned Bunyan's writing. One strand came from the chapbooks he had read in his youth. Before his conver-sion, he wrote in *Sighs from Hell* in 1658, he would say: 'Give me a Balad, a News-book, George on Horseback or Bevis of Southampton, give me some book that teaches curious Arts, that tells of old fables; but for the Holy Scriptures I cared none.

And as it was with me then, so it is with my brethren now.' Appealing directly to those unregenerate brethren, Bunyan borrowed the drama of the chapbook romance. Among innumerable other adventures, Sir Bevis of Hillier is sold into slavery to the 'Paynims', refuses to serve 'Apoline' their god, and is later thrown into a dungeon, attacked by two lions and meets 'an ugly Gyant thirty foot in length' just like Giant Despair. This inheritance, seen clearly in the text, also seeped into the illustrations, which often resemble chapbook cuts – especially Greatheart setting out with his helmet and sword, or Christian's fight with Apollyon, a favourite subject. Apollyon's shape is the dragon of folklore, though the details may come from the Book of Revelation: 'cloathed with scales, like a Fish . . . Wings like a Dragon, feet like a Bear, and out of his belly came Fire and Smoak, and his mouth was as the mouth of a Lion'. It took no effort to strip Bunyan's work of its strenuous theological arguments and turn it straight back into chapbook form: indeed, a chapbook version of *The Pilgrim's Progress* was published by Thomas Passinger as early as 1684.

Ponder's copper cuts, however, were not the only set of plates. Bunyan had many readers among Dutch Calvinists, and in 1685 Jan Luiken engraved a different set for the Dutch publishers of a Flemish translation, which are far livelier and more realistic. One of these reminds us of yet another visual tradition, the emblem. In the sweeping of the floor, the Interpreter's neglected parlour is the heart of man and the dust his sin and corruption. The fierce sweeper is the Law, who only makes things worse, and the

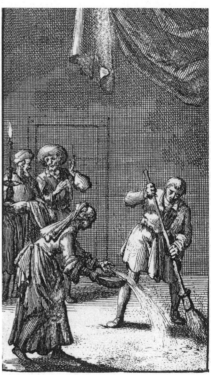

Nathaniel Ponder edition, 'Christian fights Apollyon', 1680
Jan van Luiken, 'The Man Sweeping the Interpreter's Parlour', 1685

woman is the Gospel, who sprinkles water on the dust to make the room easier to clean, 'and consequently fit for the King of Glory to inhabit'. (This image was later reworked in an engraving by Blake, who made the sinning soul into a cloud of dust that virtually filled the room, and gave the Law – always a curse in his eyes – the wings of a little demon.)

Ponder added two extra plates for Part II, which was published in 1684, describing the adventures of Christian's wife, Christiana, and her friend Mercy. But *The Pilgrim's Progress* was a victim of its own popularity. The copperplates were expensive and slow to print, so to meet demand they were copied onto woodblocks, which could be printed at the same time as the text. Not only did this make the designs cruder, but the publishers mixed the English and Dutch illustrations together, losing any sense of a coherent visual narrative.

The Pilgrim's Progress was slipping firmly towards the popular, cheaper end of the market. In 1728, the centenary of Bunyan's birth, the publishers attempted to retrieve the book's status with a fine 'centennial edition'. This contained new copperplates: the usual fourteen for Part I, plus eight for Part II. They were designed by John Sturt, a veteran engraver who had worked with Robert White, and they brought Christian elegantly up to date: as he struggles past the lions to the Palace Beautiful, he is heading for a fine Palladian mansion. Sturt's Vanity Fair, where Christian and Faithful are put in a cage by the jeering mob, had the popular 'flying men' and Punch and Harlequin of the 1720s, references later picked up by Blake,

and later still by George Cruikshank in the 1830s, whose *Vanity Fair* also contained allusions to Hogarth's *Southwark Fair* and *South Sea Scheme*, a satire on speculation and greed perfectly suited to Bunyan's text.

Hogarth admired Bunyan and drew on *The Pilgrim's Progress* to depict the counter-progresses of the Harlot and the Rake. But his real hero was Milton. In 1753, on the title page of his *Analysis of Beauty*, in which he states his artistic principles and unveils his theory of the line of beauty or 'Serpentine Line', he quoted Milton's image of the insidious dance of the serpent, with its seductive movement:

> So vary'd he, and of his tortuous train
> Curled many a wanton wreath, in sight of Eve, to lure
> her Eye.

As a young engraver in the 1720s, influenced by his father-in-law Thornhill and old teacher Cheron, Hogarth had made conventional, baroque engravings of the Council in Hell and Council of Heaven. Around fifteen to twenty years later, however – the exact date is unclear – he painted one of his most striking pictures, unlike anything else in his work *Satan, Sin and Death* depicts the encounter at the Gates of Hell from *Paradise Lost* Book II (in the colour section). Satan is about to attack Death, when his daughter Sin intervenes, explaining that Death is their son by his incestuous rape. Conflict is avoided, and Satan promises to free them from Hell and bring them to a place where

John Sturt, 'Christian passes the Lions', 1728

all things will be their prey. Hogarth follows Milton closely, showing Sin, 'Woman to the waste, and fair, / But ended foul in many a scaly fould', with the shape of Satan beside her:

> black it stood as Night
> Fierce as ten Furies, terrible as Hell
> And shook a dreadful Dart: what seem'd his head
> The likeness of a Kingly Crown had on.

But he faced a problem in the poet's deliberate vagueness about Death:

> The other shape
> If shape it might be call'd that shape had none
> Distinguishable in member, joynt or limb . . .

To suggest this non-shape, Hogarth chose a skeleton, a conventional memento mori. Several younger artists, inspired by the engraving of this ferocious, unnerving painting, copied and modified it in their own way: Fuseli in fluid ink-and-wash sketches, James Barry in powerful, sensual drawings and etchings, and Blake in an almost diagrammatic watercolour, presenting Death as a transparent shape, paradoxically alive. In all these, however, the artists followed Hayman rather than Hogarth in making Satan beautiful, muscular and mobile.

In the 1790s Hogarth's image was also picked up by the satirists, notably Rowlandson and Gillray, whose *Sin, Death and the Devil* of 1792 shows Queen Charlotte desperately intervening with Chancellor Thurlow (Satan) to save her protégé, Pitt. By

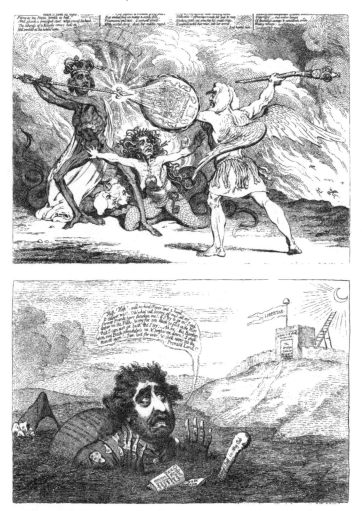

James Gillray, *Sin, Death and the Devil*, 1792
and *The Slough of Despond*, 1793

now both *Paradise Lost* and *The Pilgrim's Progress* were so deeply entrenched in the national consciousness that they offered easy frames of reference. A year later, Gillray used Bunyan's 'Slough of Despond' to attack Charles Fox, head of the Whig opposition, struggling towards the 'Way to the Patriot's Paradise' with a bundle of French gold on his back. But in the curious back-and-forward dialogue of images, Gillray's satire, too, was turned on its head. David Erdman, in *Blake: Prophet against Empire*, shows how Blake reworked a detail from this 'Slough of Despond' in 'I want! I want!', in *The Gates of Paradise* in the same year. Stepping on the ladder to the moon, Blake's pilgrim-artist aspires beyond the sensual world in his brave, if vain, attempt to reach his 'infinite desire'.

The decade after the French Revolution brought war on the Continent and treason trials at home. In this climate Milton and Bunyan could both be taken as models of defiance against oppression and Milton in particular was hailed as the supreme poet, a great patriot and an intellectual giant. Admirers ignored his awkward republicanism, acclaiming *Paradise Lost* as the great national epic. Beneath his Milton-Hogarth satire, Gillray wrote sardonically in 1792, 'The above performance ... is recommended to Messrs Boydell, Fuselli & the rest of the Proprietors of the 365 Editions of Milton now publishing, as necessary to be adopted in their classic embellishments.'

There was indeed a Milton boom, with sixty separate editions of *Paradise Lost* between 1770 and 1825. The Swiss artist Henry

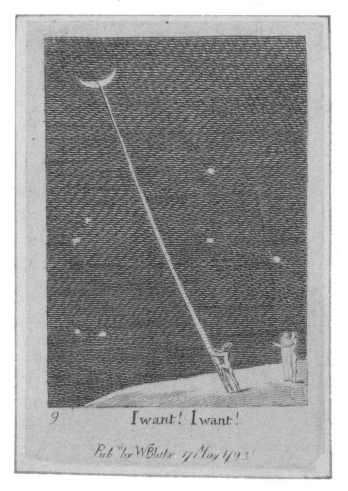

William Blake, 'I want! I want!', 1793

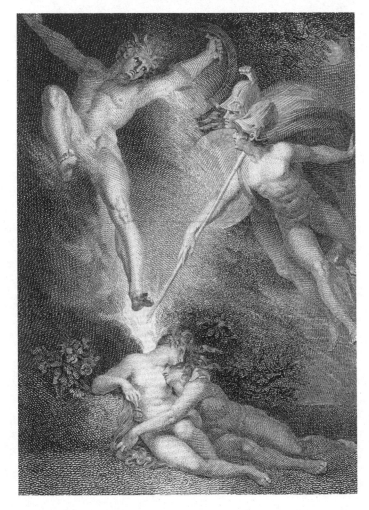

Henry Fuseli, 'Satan spying on Adam and Eve',
engraved by A. Smith, 1802

Fuseli had established his own (unsuccessful) Milton Gallery in 1799, showing fifty paintings he had produced since 1791. Among the many artists who drew *Paradise Lost*, either privately or as commissioned designs, were George Romney, Thomas Stothard (for the Boydell edition that Gillray scorned), Henry Richter, Richard Westall and Edward Burney. All celebrated the 'Heroic Milton', powerfully evoked in John Flaxman's supple, energetic line drawings of tumbling, tangled angels, in Barry's muscular 'Satan rousing his legions' – neither of these designed for publication – and in Fuseli's furious, leaping Satan spying on Adam and Eve, engraved for the du Rouveray edition of 1802.

To the poets as well as the artists, *Paradise Lost* was the embodiment of the Sublime. The young Wordsworth felt faint when reading descriptions of Satan 'from a sense of beauty and grandeur', and in 1802, in his sonnet beginning 'Milton! Thou should'st be living at this hour / England hath need of thee', he called on Milton's genius to rouse the stagnant nation to life:

> We are selfish men
> Oh! raise us up, return to us again;
> And give us manners, virtue, freedom, power.
> Thy soul was like a Star and dwelt apart:
> Thou hadst a voice whose sound was like the sea;
> Pure as the naked heavens, majestic, free . . .

The most complex poetic response was that of Blake, explored in his *Marriage of Heaven and Hell* in 1790, and in his long, semi-autobiographical, visionary poem *Milton*, where the

poet is an artist of revolutionary force, seen as Satanic by state and Church, his vision pure but its realisation distorted. Blake produced both these works as illuminated texts, but in a different mode, over a decade later, in 1807 and 1808, he produced two sets of twelve watercolours for *Paradise Lost*, for the Revd Joseph Thomas and Thomas Butts. In these illustrations, especially 'Satan arousing the rebel Angels', Blake adapted the familiar heroic Milton. But at the same time he reinvents the narratives of Genesis, making the epic sensual and intimate, as in 'Satan watching the endearments of Adam and Eve' and the erotic 'The Temptation of Eve', where the serpent of self-love – wrapped round the jealous Satan as he watches – twines itself round Eve, a herald of lust after the Fall. Blake also moved the focus from Satan – so long the hero – to the sacrifice of Christ. In 'The Son's offer to redeem man', the crucifixion pose of God and Christ mirrors Satan's outstretched arms as he summons his legions. We tend to look at these paintings one by one, but Blake's illustrations – whether it be to Gray's poems, to Milton, the Book of Job, or Dante – often make their point through sequence and pattern: the circling serpent or the outstretched arms are codes of meaning.

While Milton held sway, Bunyan was not neglected. The same period, from 1770 to 1820, saw new editions of *The Pilgrim's Progress*, illustrated by a new generation of artists like Stothard who produced a rather bland set of prints in 1788. On a cheaper level, provincial booksellers tried to beat the London trade:

John Thurston, 'Apollyon fights Christian,'
engraved by the Bewick workshop, 1806

between 1799 and 1806, for example, Thomas Bewick's wood-engraving workshop in Newcastle received requests for illustrations from booksellers in Edinburgh, Gainsborough and Taunton. The cheap Edinburgh version had rough engravings by apprentices, but drawings for the other two were provided by the artist John Thurston. The Taunton edition in particular caused a deluge of letters to Bewick about delays and designs. 'Some little objection has been made', sighed the publisher Poole, 'to the Testicles of Apollyon being so much in view'.

In this new 'age of cant', as Byron called it, decency was important. Bunyan was admired less for his vernacular

37

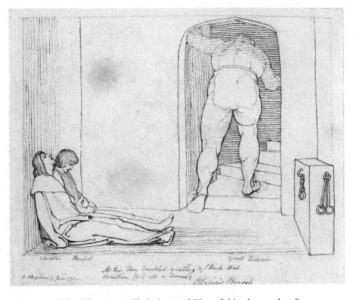

John Flaxman, 'Christian and Hopeful in the castle of
Giant Despair', *c.*1795

toughness and more for his deceptively simple-looking
'piety'. But some artists put the sectarian message to one
side and found in his work a private narrative of stoical self-
discovery. In the mid-1790s, staying in gorgeously baroque
Rome, John Flaxman turned from illustrating Homeric epic
and heroic Milton to make small line drawings of marvellous
purity of scenes from *The Pilgrim's Progress*. No one knows
what prompted them – there is no clue in his notebooks.

Thirty years later, towards the end of his life, William Blake

38

also turned to Bunyan. He had just finished the revised engravings for the Book of Job, and was on the verge of his hundred great illustrations for Dante's *Divine Comedy*. Between these, he worked on small watercolour sketches of *The Pilgrim's Progress*. His series included twenty-eight scenes, doubling the standard fourteen cuts. The watercolours are small, five inches by seven, suggesting that he was thinking of them in terms of book illustrations. But like Flaxman's drawings they were never engraved: there is no indication of what they were for or why he abandoned the project before the sketches were finished.

Earlier, Blake had disparaged Bunyan for his Puritan mentality, but he came to see his writing as transcending the dry, riddle-like quality of allegory and approaching pure imagination, the realm of the genuine artist. In 1810, in *A Vision of the Last Judgement*, he wrote: 'Fable or Allegory is Seldom without some Vision. Pilgrim's Progress is full of it the Greek Poets the same but Allegory & Vision ought to be known as Two Distinct Things & so calld for the sake of Eternal Life.' In his version of Robert White's original frontispiece, the portrait of Bunyan is transformed into the 'Dreamer', the poet, guide and channel of 'Vision', with the caged lion of the senses dreaming beneath his sleeping form.

Blake is superb, too, in conjuring Bunyan's darker side, like the depression and rage of 'The Man in the Cage', trapped in his own despair, unable to repent and believe: 'nor can all the men in the World let me out. O Eternity! Eternity! How shall

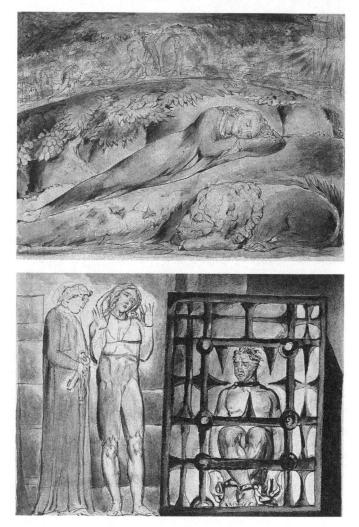

Blake, 'The Dreamer', *c.*1824;
'The Man in the Iron Cage'

I grapple with the misery that I must meet in Eternity?' The terrible cry has a Blakean ring and rhythm. And when he turns to depicting the fiend Apollyon, who 'strodled quite over the whole width of the way', Blake borrows 'the dreadful dart' and great shield from his own Miltonic 'Satan, Sin and Death' yet makes the scene powerfully intimate, showing us the terrible closeness of their embrace as Christian is pressed to Apollyon's fiery loins:

> Then Apollyon, espying his opportunity, began to gather up close to Christian, and wrestling with him gave him a dreadful fall; and with that Christian's sword flew out of his hand. Then said Apollyon, *I am sure of thee now*; and with that, he had almost prest him to death, so that Christian began to despair of life.

We know that Christian will give the demon a mortal blow: the progress must continue. And in this series, as in his Miltonic watercolours, Blake uses pattern to make his point. The scenes form a frieze, like the triptych of Christian first climbing Hill Difficulty, then resting in the arbour, where he loses his roll and returns to find it in a moment of pure joy, then climbing on again, past the lions to the Palace Beautiful. No other Bunyan illustrator approaches this intensity and rhythm.

These small paintings, formerly in the Frick Museum and now in private hands, are rarely seen. In technical terms, some experts think that their crudeness stems from their being over-painted by another hand, perhaps by Catherine Blake, while

on a theoretical plane, the critic Gerda Norvig has provided an elaborate commentary in terms of 'visionary hermeneutics'. But to me, the *Pilgrim's Progress* watercolours are at once profound and simple. They read like a private valediction to a tradition that Blake knew was coming to an end – a look back to the rough, popular art of the chapbook and the emblem, an art that would have no place in the dawning century.

'The Ancients', the group of artists who revered Blake in the 1820s, including John Linnell and Samuel Palmer, called Blake 'The Interpreter', after the figure who explains the emblems to Christian. Samuel Palmer in particular loved Bunyan, and his 1825 ink-and-sepia drawing *The Valley Thick with Corn* has been thought to represent the scene that Blake had also illustrated, of Christian resting in his arbour, his pose and costume echoing White's frontispiece of Bunyan the Dreamer. Palmer brings Bunyan back to the British countryside. But years later, in 1848, he produced a far grander painting of *Christian Descending into the Valley of Humiliation*, a lyrical, Salvator Rosa-like scene, where the small, brave figure of the Pilgrim almost vanishes against the mighty landscape. That smallness is significant. It is influenced, I think, by John Martin, the most influential of the new generation of illustrators, whose designs for *Paradise Lost* were engraved as mezzotints in 1825-7. Throughout, the protagonists are dwarfed by their settings, Satan by the 'darkness visible' of hell and Pandemonium, Adam and Eve by the park-like scenery of Eden. In the dark,

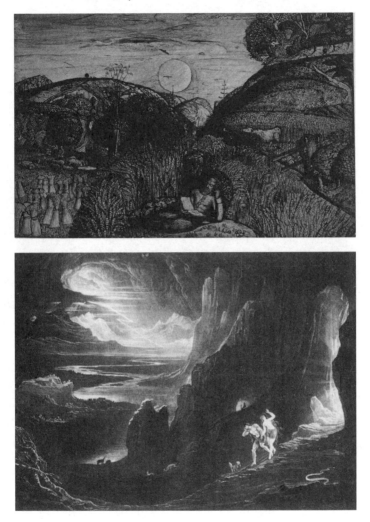

Samuel Palmer, *The Valley Thick with Corn*, 1825
John Martin, 'The Expulsion from Eden', 1827–30

dazzling scene of their expulsion, they step out of the light onto the stony mountain path, facing the spreading view of wild, elemental nature before them.

In 1828 Martin was also suggested as illustrator for a new edition of *The Pilgrim's Progress*, much to the horror of Charles Lamb. When his friend Bernard Barton told him of the plan, he recoiled:

> A splendid edition of Bunyan's Pilgrim – why, the thought is enough to turn one's moral stomach. His cockle hat and staff transformed to a smart cock'd beaver and a jemmy cane, his amice gray to the last Regent Street cut, and his painful Palmer's pace to the modern swagger. Stop thy friend's sacrilegious hand. Nothing can be done for Bunyan but to print the old cuts in as honest a style as possible. The Vanity Fair, and the pilgrims there – the silly soothness in his setting-out countenance – the Christian idiocy (in the good sense) of his admiration of the Shepherds on the Delectable Mountains, the Lions so truly Allegorical and remote from any similitude to Pidcock's. The great head (the author's) capacious of dreaming . . . Perhaps you don't know *my* edition, what I had when a child; if you do, can you learn new designs from Martin, enamelled into copper and silver plate by Heath . . .?

Alas for Lamb, in the grand edition of 1830, introduced by Robert Southey, the frontispieces were indeed engraved from paintings by Martin: an almost totally black 'Valley of the

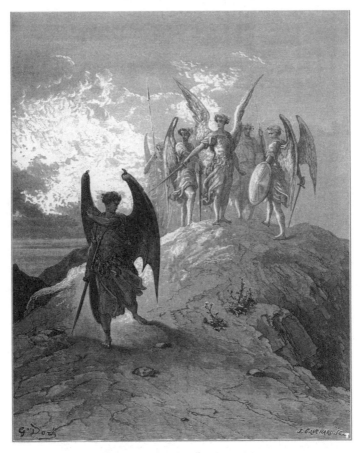

Gustave Doré, *Paradise Lost*, 1866

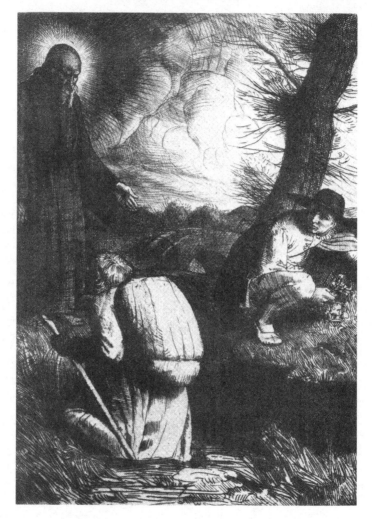

William Strang, *The Pilgrim's Progress*, 1895

Shadow of Death' and a view of the Celestial City which has been compared to a view across the Serpentine.

Martin and his heirs hurled Milton and Bunyan into a different age, where human concerns seemed to shrink beside mushrooming industry, growing cities and spreading empire, and arguments about geology and evolution. Their Victorian life is another story: with the new techniques of steel prints and lithographs, publishers would produce a host of illustrated editions. But if I had to choose two defining images from the nineteenth century, then *Paradise Lost* continues to soar, to belong to the heavens and the abyss and the militant archangels – as it does in the designs of Gustave Doré for the huge folio edition of 1866. And as for *The Pilgrim's Progress*, although it inspired Victorian missionary zeal, the finest illustrators always brought Bunyan down to earth, from Cruikshank in 1838 to William Strang in 1895. Strang's 'Slough of Despond' simply gives us a man stuck in an English ditch. While Pliable turns back, Christian struggles on, eventually pulled out by Help, offering the assistance that all pilgrims, writers and artists need from time to time. '*Then*, said he, *Give me thy hand*; so he gave him his hand, and he drew him out, and set him upon sound ground, and bid him go on his way.'

{2}

Hogarth and Fielding

Modern Moral Drama

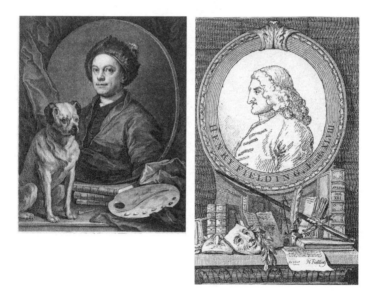

William Hogarth had grand ambitions: he wanted to be a painter of fine portraits and history paintings that would rank him with the great. He had, however, a fatal genius for satire and this crept into his portraiture, making clients understandably wary. He was an instinctive iconoclast, pushing boundaries, suspicious of models and rules, veering between art and 'entertainment'. He turned to prints, knowing he could make more money by selling to the many than through the uncertain patronage of the few. In his *Autobiographical Notes*, written late in life – and with the benefit of hindsight – he described how he embarked on work of a wholly original kind, 'Painting and engraving modern moral subjects'. He set out, he explained, 'to treat my subjects as a dramatic writer: my picture was my Stage and men and women my actors who were by means of certain Actions and expressions to exhibit a dumb shew.'

When he painted his *Self-Portrait with Pug* in 1749, to stress his literary descent, he propped up the oval portrait's painted frame on three books: Milton, Shakespeare and Swift. The last of these three was also a hero to Henry Fielding, the writer

nearest to Hogarth in his daring mix of satire and show, impassioned feeling and fierce criticism of wrongs. Hogarth's portrait of Fielding shows him with his great beaky nose in profile, like a Roman emperor on a coin. Engraved by James Basire for Murphy's edition of Fielding's works in 1762, eight years after his death, it refers to his role as magistrate, through the sword of justice and the copy of *Statutes at Large*, but also to his novels *Joseph Andrews* and *Tom Jones*, and his work as a dramatist, with the masks of comedy and tragedy. The story went round that Hogarth had such difficulty with the face that the actor David Garrick offered to 'play' Fielding, succeeding so vividly that Hogarth was completely unnerved.

Hogarth also painted Garrick himself, portraying him with astonishing power as Richard III and also in a playful domestic pose. Many of his friends were actors, or were connected with the stage, like the artists George Lambert and Francis Hayman, who both worked as scene-painters. He loved the theatre all his life, from his childhood days in Smithfield, the site of St Bartholomew's Fair, with its noisy sideshows and plays, jugglers and stalls. When he taught himself to paint, after his apprenticeship to a silver engraver and a move to engraving on copper, he turned to the stage: he was the first known artist to paint a Shakespearean scene, in *Falstaff Examining His Recruits* in the late 1720s, and the first to show a scene on stage, in his paintings of John Gay's *The Beggar's Opera*, from 1728 to 1731.

As he looked down at the stage, whether it be a high drama, a pantomime or a dance, 'seen at one view, as at the playhouse

from the gallery', Hogarth traced the patterns he would use in his art:

> The attitudes of the harlequin are ingeniously composed of certain little quick movements of the head, hands and feet, some of which shoot out as it were from the body in straight lines, or are twirled around in little circles.
>
> Scaramouch is gravely absurd as the character is intended, in overstretched movements of unnatural length of lines: these two characters seem to have been contrived by conceiving a direct opposition of movements.

Harlequin, Scaramouch and other figures of the *commedia dell'arte* were equally dear to Fielding as a young playwright in the 1730s. It was then that he met Hogarth, who was busily establishing the school of art in St Martin's Lane, working for copyright for engravers and fighting for the rights of British artists. With their effervescent energy and rule-breaking play with conventions, the two men were natural allies, although Fielding was ten years younger, and from a completely different class. Hogarth's schoolteacher father, like Dickens's, was imprisoned for debt, and he knew what it was to struggle: Fielding had been to Eton, his mother came from Somerset gentry and his father, with Irish aristocratic links, was a feckless soldier, gambler and womaniser. The contrast between pleb and patrician was reflected in their looks: Hogarth short, stroppy, square, pugnacious; Fielding tall, long-limbed, large-nosed and untidy, wearing his snuff-covered velvet coat with careless ease.

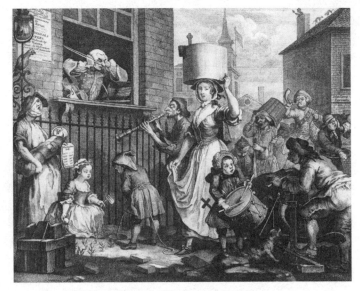

William Hogarth, *The Enraged Musician*, 1741

Both men spent their whole working lives in the area around Soho, Drury Lane and the Strand and Covent Garden. They loved plays, wit and drink and were prominent among the artists and actors thronging round Old Slaughter's coffee house. As creative spirits, they found new forms to express the debates of their time. As critics of society, they challenged authority yet performed a tightrope act between radical and reactionary: they attacked corruption as coming from above, through misuse of power and neglect of responsibility, but also saw the 'mob' as a force for potential disorder. They loved and

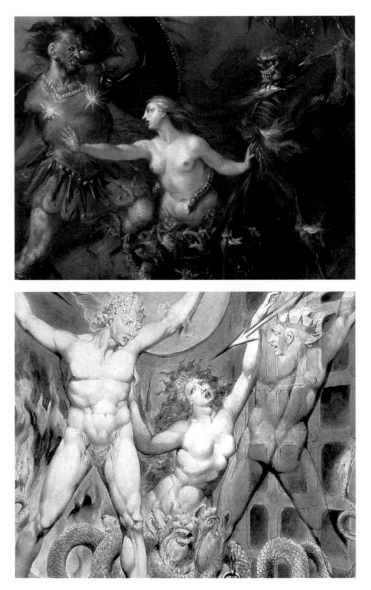

1 William Hogarth, *Satan, Sin and Death*, c.1735–40 (detail)
2 William Blake, 'Satan, Sin and Death', 1807 (detail)

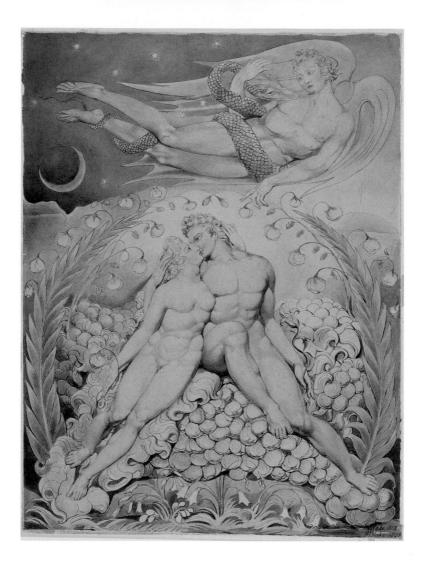

3 William Blake, 'Satan watching the endearments of Adam and Eve', 1808

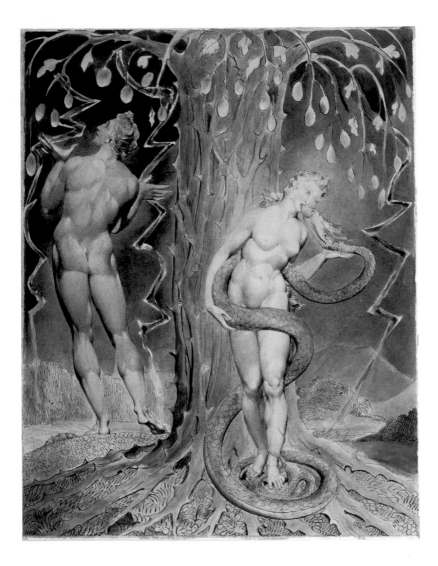

4 William Blake, 'The Temptation of Eve', 1808

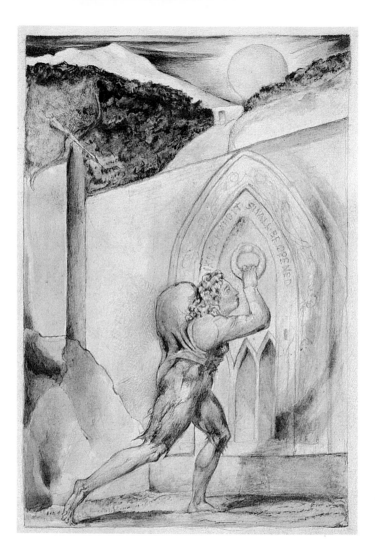

5 William Blake, 'Christian Knocks at the Wicket Gate', 1824

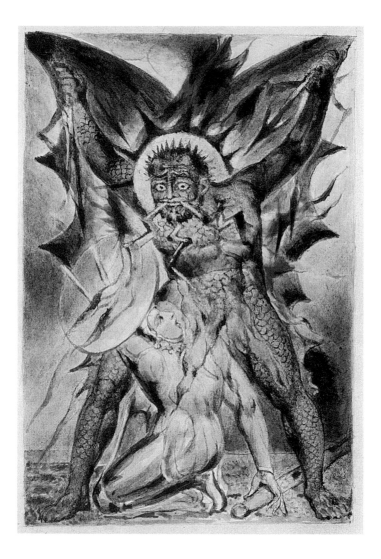

6 William Blake, 'Christian and Apollyon', 1824

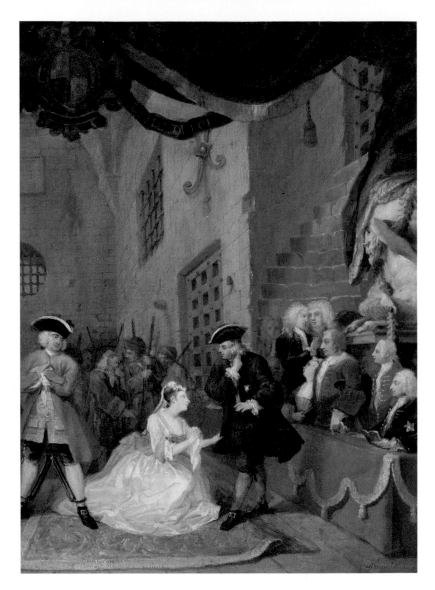

7 William Hogarth, *The Beggar's Opera*, IV, 1729 (detail)

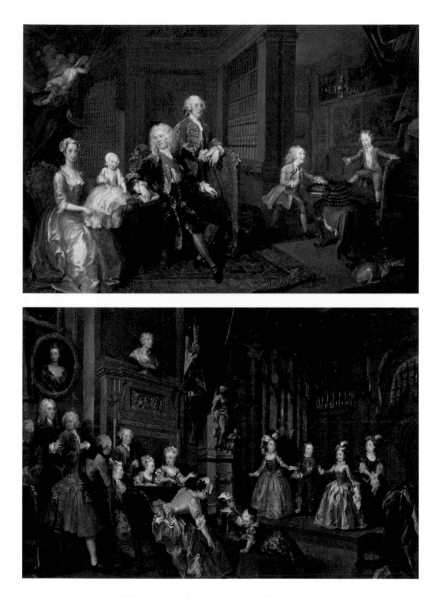

8 William Hogarth, *The Cholmondeley Family*, 1732
9 William Hogarth, *A Performance of the Indian Emperor*, 1732–5

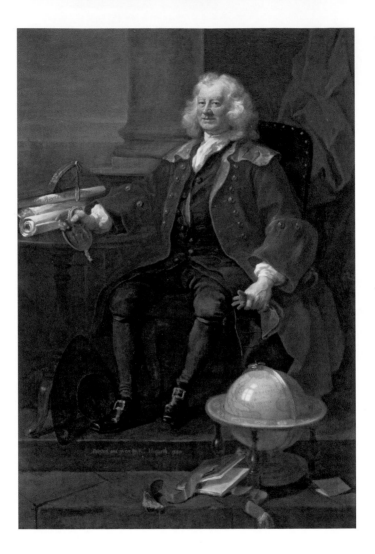

10 William Hogarth, *Captain Coram*, 1740

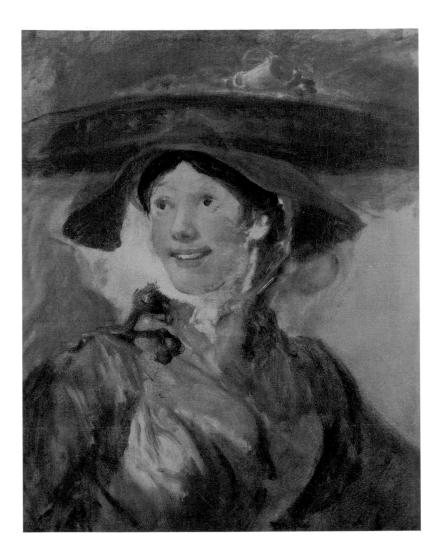

11 William Hogarth, *The Shrimp Girl*, 1740–5

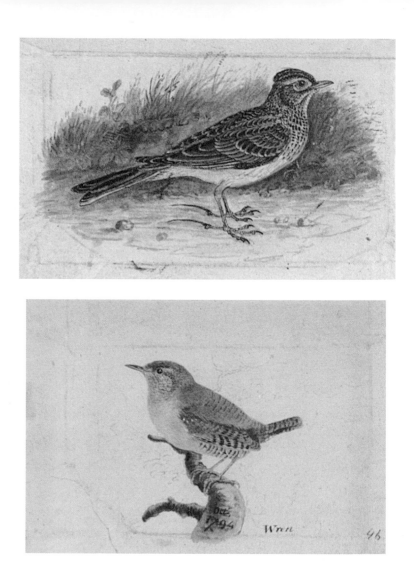

12 Thomas Bewick, *The Skylark*
13 Thomas Bewick, *The Wren*

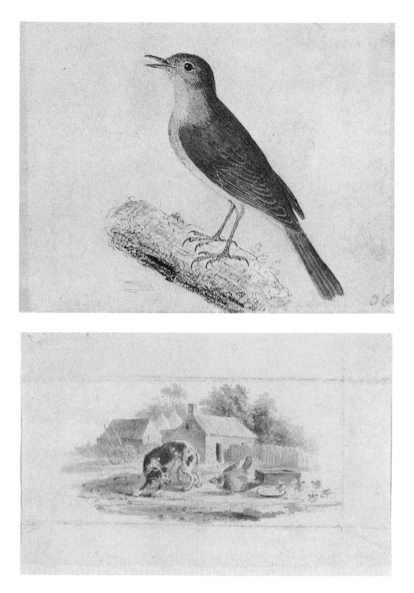

14 Thomas Bewick, *The Nightingale*
15 Thomas Bewick, *A Hen protecting her chicks*

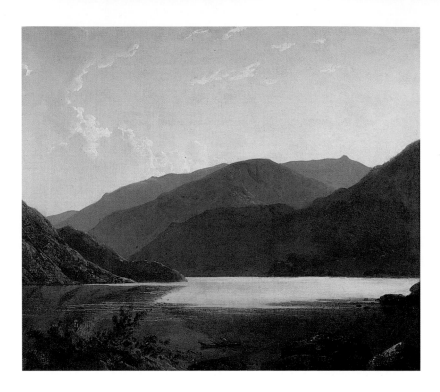

16 Joseph Wright of Derby, *Ullswater, c.*1795

feared their city – the chaotic, crime-ridden, flamboyant and filthy streets so vividly and noisily depicted in Hogarth's prints. (Fielding said Hogarth's *The Enraged Musician*, shouting from his window at the cacophony without, was 'enough to make a man deaf to look at it'.)

Hogarth's *Southwark Fair*, published in 1734, shows all the bustle of a London fair, but it is also a humorous comment on the Fall of Man, and on worldly ambition brought low, from the flying man on his rope to the banner for Settle's *Fall of Troy* and the makeshift stage for *The Fall of Bajazet* crashing noisily onto a china stall. Everyone would find easy equivalents in

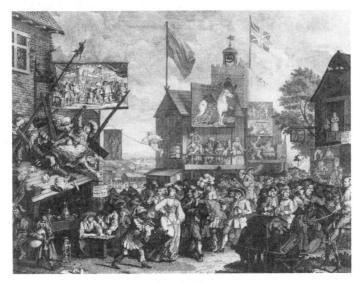

Southwark Fair, 1734

current politics for the flying men, conjurors and quacks. And every detail counted. In the show cloth for *Bajazet*, Hogarth copied a topical satire by Jack Laguerre referring to the recent 'Stage Mutiny' at Drury Lane, after one of the managers, the playwright Colley Cibber, sold his patent to John Highmore, and a rebel group of actors led by Cibber's own son walked off to the Haymarket theatre. (The mutiny, incidentally, put an end to Fielding's most successful season as a dramatist. He, too, could fall.)

Thirteen years before in 1721, the twenty-two-year-old Hogarth had launched his career with an emblematic satire, *The South Sea Scheme*, attacking foreign-style speculation and corruption, and bringing iconic city buildings together like great stage flats – the Guildhall, the Exchange, the Monument, St Paul's and the poorhouse. Death and Fortune, Honesty and Villainy were performers in a drama of power. Three years later he published *The Bad Taste of the Town, or Masquerades and Operas*. Here he took aim at the new vogues in British culture: the Palladian architecture replacing the old English style and the crowds flocking to see the pantomime *Harlequin Doctor Faustus* at Lincoln's Inn, while an old woman trundles a wheelbarrow, shouting 'Waste Paper for shops', her load including books marked Shakespeare, Otway, Congreve, Dryden and Addison. On the left, the theatre is staging Italian operas, and the Swiss impresario Heidegger leans out of the window watching people in fancy dress queue up for his fashionable masquerades.

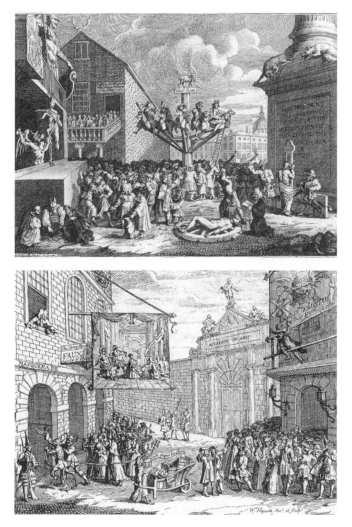

The South Sea Scheme, 1721
The Bad Taste of the Town, or Masquerades and Operas, 1724

Four years after this, Fielding made his first foray into print with a poem, *The Masquerade*, signing it 'Lemuel Gulliver, Poet Laureat to the King of Lilliput'. He, too, attacked Heidegger's frenetic gatherings:

> As in a madman's frantic skull,
> When pale-fac'd Luna is at full,
> In a wild confusion lies
> A heap of incoherencies:
> So here in one confusion hurl'd
> Seem all the nations of the world;
> Cardinals, quakers, judges dance;
> Grim Turks are coy, and nuns advance.
> Grave churchmen here at hazard play;
> Cinque-ace ten pound – done, quater-tray.
> Known prudes there, libertines we find,
> Who masque the face, t'unmasque the mind.

This year also saw John Gay's great triumph, *The Beggar's Opera*. The basic idea came from Swift, who had suggested to Pope long ago that one might have mock pastorals as well as mock-heroic epics, 'a Newgate pastoral, set among the whores and thieves there'. In Gay's play, the Beggar tells the story of the 'gentlemanly' highwayman Macheath, beloved both of Polly, daughter of the crooked thief-taker Peachum, and of Lucy, daughter of the gaoler Lockit. Both claim him as husband, fighting over him but begging their fathers not to let him swing. In Hogarth's painting, standing in the classic stage

pose of melancholy lover, Macheath has to choose between them:

> Which way shall I turn me? How can I decide?
> Wives, the day of our death, are as fond as a bride.
> One wife is too much for most husbands to hear
> But two at a time there's no mortal can bear . . .

Hogarth painted several versions, showing an increasing subtlety. His stage, which was never a precise documentary rendering, became grander, vaulted and dark, more like a real prison, at the same time as the presence of the audience on stage emphasised the artifice. This Hogarthian tension between realism and art would also be a key technique of Fielding's fiction, rupturing the suspension of disbelief by making the narrator address the reader, as in the chapter headings of *Tom Jones*: 'A Crust for the critic', 'Containing Five pages of paper', 'Shewing what Kind of a History this is: what it is like, and what it is not like', 'A most dreadful Chapter indeed and which few readers ought to venture upon in an evening, especially when alone'.

The acknowledgement of the audience was key to the success of Fielding's novel and Hogarth's paintings. Was Hogarth satirising the fashionable playgoers just as Gay's tunes mocked the vogue for Italian opera? In the final versions, the audience contained a drama of its own, which delighted all those in the know. Now Polly Peachum stretches out her hand, not backwards to her father, as in earlier versions, but towards a small

upright figure, wearing the Star of the Garter. This is the Duke of Bolton, who fell in love with the actress Lavinia Fenton on the first night, returned every evening and swept her off-stage as his mistress at the end of the season – their affair was the talk of the town. (Many years later, when his wife died, he married her.)

The spectators watch each other, not the cast. But even so, the real action, as in *The Laughing Audience* of 1733, may be happening behind their backs. And we, too, are spectators, as Hogarth reminds us in two mottos written across the ribbon swags of *The Beggar's Opera* curtain, the proverbial Latin phrase, *veluti in speculum*, even as in a mirror, and *utile dulci*, Horace's definition of the power of theatre, useful and pleasant. Fielding would use a similar quotation in 1740 in his journal *The Champion* to explain the teaching power of satire, quoting from Terence's play *Adelphi*: '*Inspicere tamquam in speculum in vitas omnium / Jubeo atque ex aliis sumere exemplum*', 'We should look at the lives of all as in a mirror, and take from others an example for ourselves.' And if the mirrored scene makes us laugh, so much the better.

After his brief spell in London in 1728 Fielding set off to university in Leiden, coming back so broke, he told his relative Lady Mary Wortley Montague, that he had to choose either to be 'a hackney Writer or a hackney Coachman'. There was a boom in London theatre, with new 'little theatres' springing up alongside the official patent theatres, and here Fielding found a home, writing over twenty plays. He was a serious dramatist,

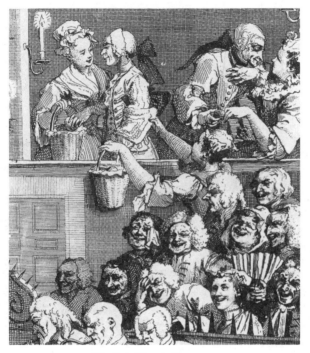

The Laughing Audience, 1733

adapting Molière and Restoration comedy, but he also wrote the 'irregular dramas' that were put on after the main show, mixing satire, burlesque, puppet show, ballad opera and ballet.

These exuberant, clever plays are in what one of his characters calls 'the Emblematical mode', like Hogarth's *South Sea Scheme*. Their fast-paced plots are elaborately unrealistic, with surreal flights of fantasy, linguistic play and layers of reference.

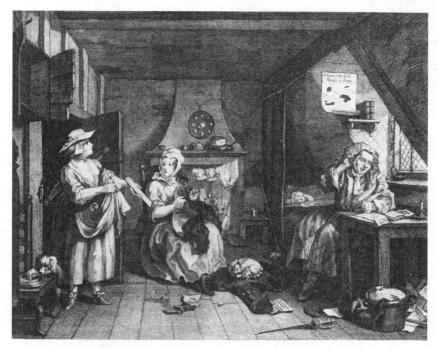

The Distrest Poet, 1740

Fierce moral and political comment is combined with sheer absurdity. His first great hit was *The Author's Farce* in 1730 – full of thinly disguised topical characters – in which an impoverished playwright, rejected by the big theatre managers, puts on an old puppet play in despair, combining the fairground Punch and Judy with scenes from the Underworld, ruled by the Goddess of Nonsense. In a mad climax the 'real life' of the plot,

and the fantasy of the play within a play, become completely intertwined: as in a Shakespearean revelation scene, everyone turns out to be related to everyone else, including the puppets. But even beyond this, the actors in both main plot and play are given 'real' off-stage lives, failing to turn up because they have lost their gloves, have to meet someone, or are simply too drunk.

The poor author's situation is, of course, very like that in Hogarth's revised version of *The Distrest Poet*, where the milk-maid demands payment, the baby is tucked up under a print promising gold mines in Peru, and the poet writes on 'Riches', while the *Grubstreet Journal* lies on the floor. This was also perilously close to Fielding's real-life situation: he had to write to pay the bills, and his friend Arthur Murphy recalled him late at night in the tavern, scribbling ideas on scraps of tobacco paper.

Another of Fielding's hits was *Tom Thumb*, its barbed plot bringing the chief minister, Robert Walpole, literally down to size. When this was revised as *The Tragedy of Tragedies*, pub-lished with a mass of spoof learned notes, Hogarth drew the frontispiece (engraved by Gerard van der Gucht), featuring Princess Huncamunca, whom many took to be a caricature of Queen Caroline. Both artist and writer followed Gay's lead in using low life to criticise high. Thus in 1732 Fielding put on *The Covent Garden Tragedy*, a burlesque of Ambrose Phillips's neoclassical drama *The Distrest Mother*. The prologue explains how the playwright has turned from Greece and Rome in search of 'nectar' nearby and now:

From Covent Garden culls delicious stores
Of bullies, bawds and sots, and rakes, and whores.
Examples of the great can serve but few;
For what are kings' and heroes' faults to you?
But these examples are of general use.
What rake is ignorant of King's Coffee-house?

Frontispiece to *The Tragedy of Tragedies*, 1732

In tune with this, Fielding replaced Phillips's heroine
Andromache with 'Mother Punchbowl', a clear nod towards a
notorious bawd, Mother Needham, and an equally clear trib-
ute to Hogarth's successful prints of *A Harlot's Progress*,
published that year. In Hogarth's first scene, the innocent Moll
gets down from the York coach and while the clergyman turns
his back Mother Needham sizes her up for the man lurking in
the doorway behind. This is Walpole's crony Lord Charteris,
recently acquitted of raping a servant, much to the fury of the
London crowds.

Fielding often had these prints in mind, calling 'the in-
genious Mr Hogarth . . . one of the most useful satirists any age
hath produced'. Both men also linked their attacks on corrup-
tion to the hypocrisy of 'good taste', the cultural blindness
matching the moral. The second scene in *A Rake's Progress* of
1735 shows the miser's son squandering his inheritance in a
room hung with bad copies of Old Master paintings. Among
the 'Artists and Professors' are a French dancing master and a
recognisable back view of Handel at the harpsichord, with the
endless cast list of castrati and rapacious sopranos for his latest
opera thrown over his shoulder.

By the time of *A Rake's Progress* Fielding was entertaining
Drury Lane audiences with plays like *Pasquin* and the
Historical Register, where Walpole was pilloried as the fiddler
Quidam, bribing patriots to make them dance. Outraged, in
1737 the government passed the Theatre Licensing Act,
restricting playhouses to those with official patents. Fielding's

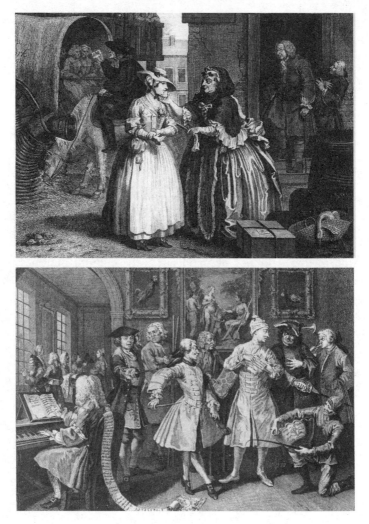

'Moll arrives in town', *A Harlot's Progress*, 1732
'Surrounded by Artists and Professors', *A Rake's Progress*, 1735

dramatic career was at an end. In January 1738 when the new Act came into force, Hogarth published *Strolling Actresses Dressing in a Barn*, where the 'Act against strolling players' lies in the foreground. The backstage chaos includes crowns mixed with chamber pots, a kitten playing with an orb and a monkey peeing in a helmet. A dishevelled Diana poses with her hoop round her feet and her quart pot and pipe propped on a makeshift altar, while Juno stretches her leg out on a wheelbarrow for the Goddess of Night to darn her stocking.

Packed, energetic and excessive, *Strolling Actresses* debunks pretence while acknowledging the force of art, the delight in transformation, the sheer urge to believe. It is fun even if you miss the classical allusions, but these undoubtedly enrich our enjoyment: both Hogarth and Fielding assume an audience who understands the context and will grasp the overlapping references and join in the games. Fielding's play *Tumble-Down Dick* has similar comic problems, with props and dirty linen and inadequate costumes for stage gods and goddesses. Play and print are manifestos. Both men are concerned with reality and illusion, determined to strip the façade, to look behind the scenes, like the peeping Tom on Hogarth's barn roof who peers at the undressed actress – and who would do well to recall Actaeon's cruel fate when he saw Diana bathing.

The theatrical undressing, the dangerous stripping off of the masks of the powerful, is part of Hogarth's and Fielding's moral agenda. But there is a tension in their work between

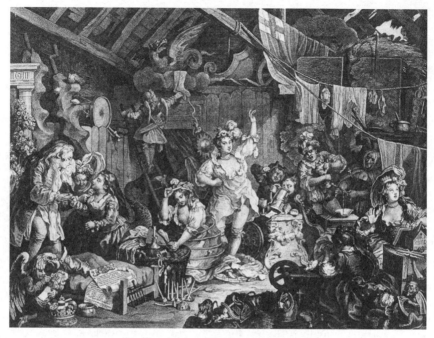

Strolling Actresses Dressing in a Barn, 1738

battling ideas. On the one hand they share their age's legacy from Hobbes, the belief that mankind is essentially selfish, and that culture and religion are modes of socialising 'fallen' instincts, expressed in Hobbes's famous statement that if left in a natural, uncultured state, man's life would be 'solitary, poore, nastie, brutish and short'. In *Leviathan* (1651), Hobbes had discussed the difficulty of judging by appearance 'which disguiseth the face as a mask or Visard'. He also made the con-

nection between 'person' and 'persona', the Latin word origi-
nally used for an actor's mask: 'So that a person, is the same
thing that an actor is, both on the stage and in common con-
versation, and to personate is to act, or represent himself or
another.'

Hogarth and Fielding both faced the problem of how to
represent a 'person', how to indicate the underlying person-
ality and separate the genuine individuals from the 'masks' that
surround them. Fielding discussed this through the familiar
image of the masquerade, in his 'Essay on the Knowledge of the
Characters of Men' in 1743:

> Thus while the crafty and designing Part of Mankind,
> consulting only their own separate Advantage, endeavour
> to maintain one constant Imposition on others, the whole
> World becomes a vast Masquerade, where the greatest Part
> appear disguised under false Vizors and Habits; a very few
> only showing their own Faces who become, by so doing,
> the Astonishment and Ridicule of all the rest.

Fielding wrote his burlesque *Shamela* in 1740 in a rage at
the phoney realism of Richardson's *Pamela*, a cloak, he felt,
for false morality. In his fiction, he gives his blessing to those
who 'show their own faces', with all their flaws and unconven-
tional ways, in characters such as Joseph Andrews, Parson
Adams, Tom Jones and Amelia Booth. Similarly, in one of his
finest portraits, of the founder of the Foundling Hospital,
Captain Thomas Coram (1740), Hogarth deliberately places a

'genuine' character – who refuses to wear a wig, and whose feet tap impatiently to be off – amid the trappings of a court portrait.

Hogarth's 'conversation pieces', innovatory group paintings of families and friends, often imply that the culture of 'politeness' – which was so useful in smoothing the bumps in the new, mixed society of courtiers and money men – inevitably involved a rehearsed performance. While he celebrates polite ease, he simultaneously points to the staginess of such groups by introducing subversive details, like the ruffled rug and the excited child toppling the heavy books in *The Cholmondely Family* of 1732, or the double act in *A Performance of the Indian Emperor* of 1732–5, where the children of the great and good perform Dryden's drama of love and conquest on stage, while their aristocratic parents act out their own comedy of manners in the audience.

Yet despite their acceptance of the artificial nature of culture, Fielding – and to a lesser extent Hogarth – rejected Hobbes in favour of the more benign attitude of Shaftesbury, whose *Characteristics of Men, Manners, Opinions and Times* (1711) had promoted the ethics of Roman republicanism as a model for the new 'Augustan Age'. This ideal, of course, was rarely realised. (Hogarth's view of how closely eighteenth-century Britain approached Augustan virtues is illustrated in the tavern scene from *A Rake's Progress*, where the walls above the spitting whores are decorated with portraits of Roman emperors, all of them defaced – except Nero's.) Individual

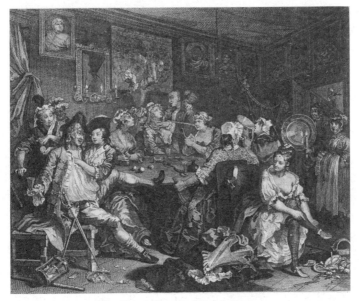

'The Tavern Scene', *A Rake's Progress*

choices were always hard, but Shaftesbury's optimistic belief held that the ethics of government should be governed by moral principles rather than pragmatism. Men's affections were not merely selfish, as Hobbes declared, but were channels of fellowship and social cohesion: 'A public spirit can only come from a social feeling or sense of partnership with human kind.'

While Fielding attacks hypocrisy, in the essays published in *Miscellanies I* in 1743, he advocates a rigorous, practical goodness, springing from sympathy. The guiding principle is

'good-breeding', but this has little to do with class. Anyone who

> from the Goodness of his Disposition or Understanding, endeavours to his utmost to cultivate the Good-humour and Happiness of others, and to contribute to the Ease and Comfort of all his Acquaintance, however low in Rank Fortune may have placed him, or however clumsy he may be in Figure or Demeanour, hath, in the truest sense of the Word, a Claim to Good Breeding.

Benevolence is its own reward. Thus Tom Jones does not envy the slimy Blifil his riches. What are worldly goods, he asks, compared to the 'warm, solid Content, the swelling Satisfaction, the thrilling Transports, which a good Mind enjoys in the Contemplation of a generous, virtuous, noble, benevolent Action?' But even here Fielding nudges the reader, like Hogarth ruffling the rug in a conversation piece, and undercuts his own message by making his hero – who has drunk a good bottle of wine – use language comically true to his sexy self.

A similar programme of active benevolence was promoted by Hogarth in his murals for St Bartholomew's Hospital in 1736. *The Pool of Bethesda* and *The Good Samaritan* caused a storm because he introduced realistic sick, poor, maimed people into a painting that recommended an ideal. Instead of 'dignity and grace', Horace Walpole sighed in his *Anecdotes of Painting*, 'the burlesque turn of his mind mixed itself with the most serious subjects' (this could almost be a description of Fielding's

fiction). But in Hogarth's view, charity is the foremost virtue, above both artistic rules and religious laws. We must learn to see the poor and sick and help them. Appearances are not all. The most unlikely person may be the true Good Samaritan, like Moll's old maid who tends her at her death in *A Harlot's Progress*, while the smart doctors are quarrelling, concerned only for their fee, or the Postillion in Fielding's *Joseph Andrews*, a boy later transported for 'robbing a Hen-roost', who gives Joseph his coat when he lies beaten and naked in a ditch while

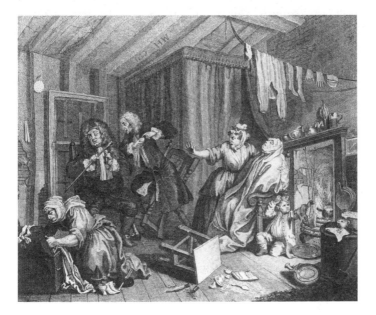

'She expires, while the Doctors are Quarrelling', *A Harlot's Progress*

the occupants of the coach refuse to take him in – the lady out of prudery, the lawyer out of fear.

Artist and writer shared a belief in practical, unsentimental philanthropy. One of Hogarth's principal causes – far from disinterested, because it also provided a showcase for British art – was the Foundling Hospital. In *Tom Jones* (1749), Fielding too attacks the prejudice against foundlings, notably when the housekeeper Mrs Wilkins discovers the baby in Squire Allworthy's bed:

> 'I don't know what is worse', cries Deborah, 'than for such wicked strumpets to lay their sins at honest men's doors . . . For my own part, it goes against me to touch these misbegotten wretches, whom I don't look upon as my fellow creatures. Faugh, how it stinks! It doth not smell like a Christian'.

She changes her tune fast when the Squire's sister Bridget kisses the baby: 'Oh the dear little creature! Dear sweet pretty creature!' The whole book teaches us how to sniff out 'a Christian', to tell the true from the false. As one clue to character, Fielding suggests that a good likeness of Bridget Allworthy had been painted by 'a more able master, Mr Hogarth . . . in his print of a Winter Morning, of which she was no improper Emblem, and may be seen walking (for walk she doth in the print) to Covent Garden church, with a starved foot-boy carrying her Prayer-book'.

*

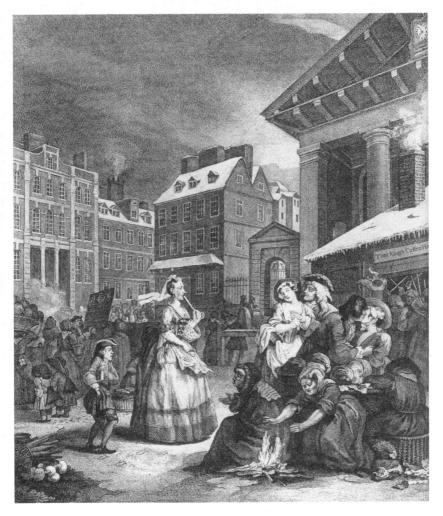

'Morning', *The Four Times of the Day*, 1738

Fielding and Hogarth were deliberately sending shock waves through the Establishment. At Old Slaughter's and at their parodic club, the Sublime Society of Beefsteaks, which met in the painting room at Covent Garden, they egged each other on, inventing new genres, puffing new ventures. From 1740 they had been open advocates of each other's work. In *The Champion*, Fielding wrote of Hogarth:

> In his excellent Works you see the delusive scene exposed with all the force of Humour, and on casting your eyes on another Picture you behold the dreadful and fatal consequence. I almost dare affirm that those two Works of his, which he calls the Rake's and the Harlot's Progress, are calculated more to serve the cause of Virtue and for the preservation of Mankind, than all the folios of Morality which were ever written and which a sober Family should no more be without than without the Whole Duty of Man in their house.

Like Tom Jones's hymn to benevolence, this is both genuine and tongue-in-cheek. Fielding is writing as 'Captain Hercules Vinegar' and doubtless expects a wry laugh from his readers when they imagine Hogarth's brothel scenes being treated as moral lessons in the 'sober family' scene.

But the humour sugared the pill. In the Preface to *Joseph Andrews* in 1742, Fielding asks 'whether the same Companies are not found more full of Good Humour and Benevolence after they have been sweeten'd for two or three hours with

Entertainment of this kind, than soured by a Tragedy or a grave Lecture'. In his novel, he says, he is attempting a new form, 'a comic Epic-Poem in Prose', between burlesque and romance. He likens this to the works of a 'Comic History-Painter', who copies nature, compared to Italian *Caricatura*, which displays monsters, not men. It would be unjust, he adds, to call Hogarth a caricaturist: it is far easier to depict a

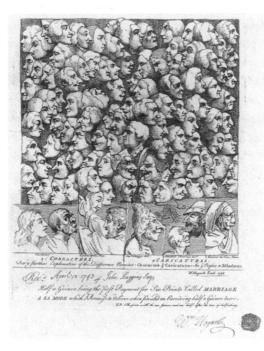

Characters and Caricaturas, 1742

77

huge nose or an absurd pose, than to 'express the Affections of Men on Canvas. It hath been thought a vast Commendation of a Painter, to say that his Figures *seem to breathe*; but surely, it is a much greater and nobler Applause, *that they appear to think.*' In reply, Hogarth engraved *Characters and Caricaturas*, the subscription ticket for *Marriage à la Mode* in 1742, a pattern of profiles, with three heads from the Raphael cartoons below, opposite four grotesques. The caption refers people for an explanation to 'the Preface to Jos. Andrews'. In the middle, in the second row, two true caricatures grin at each other, one with the beaky nose of Fielding and the other the squat snub-nose of Hogarth.

The two men, bracketed in the public's mind, worked ever more closely together. In 1747–8 Hogarth drew the frontis-piece for Fielding's ironic *Jacobite's Journal*, in which he lampooned the opposition as blustering John Trott-Plaid. And when Fielding became Justice of the Peace for Westminster in July 1748, and then for Middlesex in 1749, Hogarth supported him. A tough but compassionate Justice, Fielding made MPs visit the homes of the poor where they could see 'such Pictures of human Misery as must move the Compassion of every heart that deserves the name of Human'. But although he was committed to reform, he also feared the anarchy of the crowd and the popular culture that glorified law-breaking. He recommended private executions, not for humane reasons, but because he saw – as he had shown in

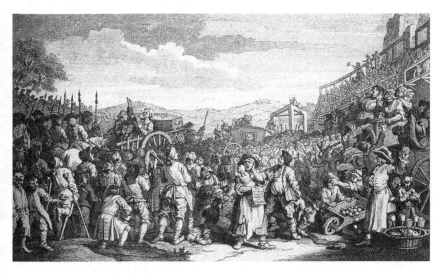

'The Idle 'Prentice Executed at Tyburn', 1747

Jonathan Wild, and as Hogarth had suggested in the riotous print 'The Idle 'Prentice Executed at Tyburn' – how the ghoulish spectacle made heroes of villains. But, like Hogarth in *Industry and Idleness*, Fielding also expressed horror at the 'many cart-loads' of fellow citizens being carried to the slaughter when 'with proper Care and regulations':

> Much the greater part of these Wretches might have been made not only happy themselves, but very useful Members of society. Upon the whole, something should be, Nay, must be Done . . . not only the care for Public Safety,

but Common Humanity, exacts our concern on this Occasion.

In January 1749, in *A Charge to the Grand Jury* he asked citizens to be 'Censors of the Nation' attacking the evils that foster crime. His attitude was ambivalent: the luxury of riches brought prosperity and employment, but it encouraged emulation and false expectations, making those at the bottom prey to crime and gambling. In *An Enquiry into the Causes of the Late Increase of Robbers* (1751) he defined the constitution as including statutes, common law and official provisions but also the 'Customs, Habits and manners of the People'. He openly linked crime to poverty, attacked the current Poor Laws and called for an end to the new epidemic of drinking, especially 'this Poison called Gin . . . the principal sustenance (if it may be so called) of more than a hundred thousand people in the metropolis'.

Hogarth's *Gin Lane*, and its companion *Beer Street*, were deliberate contributions to Fielding's campaign to amend the Gin Act, by licensing premises and stopping the sale of dangerous adulterated liquor. *Gin Lane* is still an image of dizzying power. Against the backdrop of the slums of St Giles, the stupefied woman – perhaps an image of the nation, a drunken Britannia – lolls on the steps before a veritable stage, dropping her baby into the abyss. Hogarth altered his style and his price to suit his audience, a practice he continued in *The Four Stages of Cruelty*, published six days later. Here, in the story of Tom

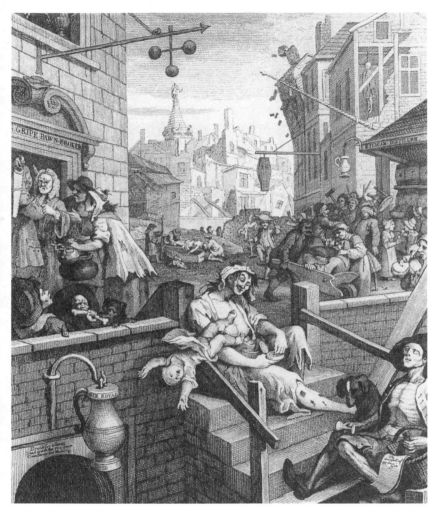

Gin Lane, 1751

Nero, he traces the progress from the casual cruelty of children torturing animals to violence and murder: but he concludes with a vision of the authorities' indifference to suffering, the anatomist's dissecting room, where Tom's corpse is disembowelled before a gaping audience.

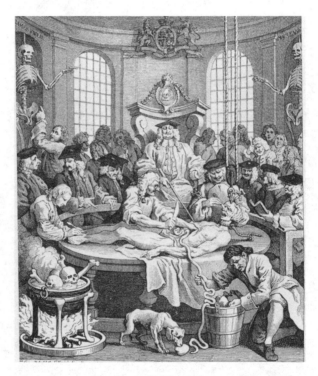

'The Reward of Cruelty', 1751

Fielding and Hogarth had worked alongside each other as satirists, rule-breakers, comedians and reformers – and perhaps they shared, at the end, a similar disillusionment, falling out of love with their laughing audience. Fielding's last novel, *Amelia* (1751), disappointed his eager readers. A study in deception and self-interest, it returned full circle to the theme of masquerade – when his heroine Amelia literally removes her mask she reveals her beauty despite a broken nose, but her innocence shines palely in the dark world of prison and sponging houses.

In 1754, very ill, Fielding sought a last desperate cure in the fine climate of Portugal. In his *Journal of a Voyage to Lisbon* he wrote that he had decided to renounce his old models in favour of truthful representation: 'For my part, I must confess I should have honoured and loved Homer more had he written a History of his own Times in humble Prose.' Both he and Hogarth had chronicled their times, mixing hard realism with fantasy and excess, capturing characters on the wing, in the middle of rush and gloom and squalor, Fielding in his plays, journalism and novels, Hogarth in his prints and portraits and private sketches, like *The Shrimp Girl*. In the dedication to *Tom Jones*, Fielding had declared that he intended to employ 'all the Wit and Humour of which I am Master . . . to laugh Mankind out of their Follies and Vices'. This, too, was Hogarth's aim. Both forged new forms, combining realism, allusion and humour, staging their modern moral dramas in incisive pictures and enduring words.

Wordsworth and Bewick

'The Poet of the Tyne'

In January 1798 Thomas Bewick was forty-four, running a busy trade-engraving business in the heart of Newcastle. He was already known for his brilliant, closely observed illustrations to a book of animals, *A General History of Quadrupeds*, written with his partner Ralph Beilby in 1790, and for *Land Birds* in 1797, the first of two proposed volumes of *A History of British Birds*: the second, *Water Birds*, would appear in 1804. William Wordsworth, by contrast, was just starting out. He was now twenty-eight, and from January to midsummer he was living at Alfoxden in the Quantocks with his sister Dorothy, only a mile or two from Coleridge's household at Nether Stowey, in a country of green hills, wheat and sheep, very different to the 'Sublime' Lake District to which he would soon return, to settle in Grasmere.

Wordsworth and Coleridge had hatched their plan for a collection of 'Lyrical Ballads', and were scrabbling to find pieces for the volume, which was put together at top speed to raise funds for a trip to Germany. As well as unpublished poems, it included lyrics written by Wordsworth that spring and early

summer, and four poems by Coleridge, including *The Rime of the Ancient Mariner*. A last-minute addition was 'Tintern Abbey', composed after Wordsworth left Alfoxden in late June. 'No poem of mine', he wrote later, 'was composed under circumstances more pleasant for me to remember than this. I began it upon leaving Tintern, after crossing the Wye, and concluded it just as I was entering Bristol in the evening, after a ramble of four or five days, with my sister. Not a line of it was altered, and not any part of it written down till I reached Bristol.'

When *Lyrical Ballads* was published anonymously in October, the Wordsworths and Coleridge were already in Germany. Huddling by wood-stoves in the icy winter, William took over Dorothy's notebook for her German lessons and began writing blank verse about his boyhood. Among other incidents, he remembered a friend hooting through his hand to the owls, in what would become one of the best-loved passages of the *Prelude*:

> There was a Boy; ye knew him well, ye cliffs
> And islands of Winander! – many a time,
> At evening, when the earliest stars began
> To move along the edges of the hills,
> Rising or setting, would he stand alone,
> Beneath the trees, or by the glimmering lake;
> And there, with fingers interwoven, both hands
> Pressed closely palm to palm and to his mouth

> Uplifted, he, as through an instrument,
> Blew mimic hootings to the silent owls,
> That they might answer him.

In the pauses when the owls were silent, and when nothing could be heard but the distant waterfalls,

> the visible scene
> Would enter unawares into his mind
> With all its solemn imagery, its rocks,
> Its woods, and that uncertain heaven received
> Into the bosom of the steady lake.

When he read that final image, Coleridge wrote: 'had I met these lines, running wild in the deserts of Arabia, I should have instantly screamed out "Wordsworth!"' This is indeed the grand, generalised landscape imbued with feeling, that we think of as 'pure Wordsworth': if we were hunting for an artist to parallel this brooding solemnity, we might choose a painting like Joseph Wright's *Ullswater*, a watercolour by Cotman or an atmospheric scene by Turner.

Wordsworth, however, was also writing in a different voice, penning ballads about the people he remembered, their oddities and quirks. Immediately after 'There was a Boy', he jotted down a long poem, 'The Two Thieves', about old Daniel and his grandson, stealing wood-chips from the carpenter and turves from the farmer's wife, 'described from the life, as I was in the habit of observing when a boy at Hawkshead

School'. He began, however, not by referring to his own memory, but to the engravings of Bewick:

> Oh now that the genius of Bewick were mine
> And the skill which he learn'd on the banks of the Tyne
> Then the Muses might deal with me just as they chose
> For I'd take my last leave both of verse and of prose.

> What feats would I work with my magical hand!
> Book-learning and books should be banish'd the land
> And for hunger and thirst and such troublesome calls
> Every ale-house should then have a feast on its walls.

As I have noted before when writing on Bewick, an extra verse in the manuscript version explicitly contrasted Bewick's cheap woodcuts to the idealised art of Joshua Reynolds's Royal Academy, which drew a clear line between the fine arts and the 'mechanical arts', accepting painting, sculpture and architecture and excluding technical drawing, decoration and engraving:

> Oh! Now that the boxwood and graver were mine
> Of the Poet who lives on the banks of the Tyne
> Who has plied his rude tools with more fortunate toil
> Than Reynolds e'er brought to his canvas and oil.

The carelessly tossed-out lines show Wordsworth taking a radical stand in the politics of the art.

It doesn't do to take 'The Two Thieves' too seriously – it's not one of Wordsworth's best efforts. The allusion to Bewick is a

tribute, but it's employed here to indicate the particular 'rustic' mode that Wordsworth himself is using; he wants his readers to see in their minds Bewick's little vignettes of country life and to recall the earlier crude woodcuts that adorned the walls of cottages and inns. He is excusing his own roughness, the quaintness of the jingling ballad form. But his lines still set off an interesting line of thought. In what sense can an engraving be a 'poem'? And what kind of poet might Bewick be? Thinking of Wordsworth's writing in 1798, one can see how his engravings might suit 'The Two Thieves', but what about 'Tintern Abbey'?

When Wordsworth called Bewick a poet, he was setting aside Bewick's skill as a naturalist and thinking only of the shrewd, entertaining tailpieces that often followed the descriptions of birds and animals in his books. Many of these – which Bewick punningly called 'tale-pieces' – tell a story and imply a moral: in this sense only do they replace 'book-learning'. The man

swimming his cow across the river to avoid the toll, for example, would make local people laugh, noticing how as the cow swims serenely on the farmer flounders and loses his hat – a new one would cost him far more than the halfpence he had saved.

The humorous vignettes are literary, in that they resemble proverbs, anecdotes or ballads. Bewick grew up in the Tyne valley, in a small community linked to the wider world through fairs and markets, and energetic traditions of storytelling and ballad-singing. In 1781, during the American War of Independence, he was outraged when the Newcastle Corporation banned singing-clubs in public houses, considering them likely sites of subversion. Missing the music, he asked a well-known Northumbrian piper to play for them, 'and with his old tunes, his lilts, his pauses & his variations', he wrote, 'I was always excessively pleased'. In his own engravings he played with form like a musician improvising on a theme: the composition of the tailpieces, with a main subject commented on by subsidiary details, is like a song with a sudden turn in the last stanza.

Unlike Wordsworth, Bewick never went to university, but he was an intelligent man who studied past masters of his craft, like Dürer, and built up a library of prints. Despite this, his country background and his seemingly effortless line often led critics to call him a 'natural' artist, in the way they described the equally sophisticated Robert Burns a 'natural poet'. In 1838, William Howitt described Bewick as 'the very Burns of wood-cutting' and Ruskin made the same comparison. This had already been used by Bewick's young friend George Atkinson, but in more considered terms. Bewick and Burns, Atkinson felt, had 'the same strength of understanding, keenness of observation, and simple originality of thought and expression', as well as a matching humanity and tenderness, quick perception of the ridiculous and profound regard for nature. Bewick would have been pleased, since Burns was one of his favourite poets and the workshop illustrated collections of his work. It is easy to see the ground they shared – a rootedness in a certain area and dialect, a love of songs, a dry wit, an unsentimental sympathy for the poor, for wild creatures, and blighted dreams.

Bewick's local scenes appealed to critics. In 1805 the journal *The British Critic* praised the tailpieces for taking 'subjects of common and familiar life, such as have not been touched by other artists, but full of characteristic truth, and frequently of original humour'. This sounds very like Wordsworth's aim, stated in the 1802 revision of his preface, 'Observations Prefixed to *Lyrical Ballads*', to choose

incidents and situations from common life, and to relate or
describe them, throughout, as far as was possible in a selec-
tion of language really used by men, and, at the same time,
to throw over them a certain colouring of imagination,
whereby ordinary things should be presented to the mind
in an unusual aspect.

Wordsworth and Bewick were both men of the north. They
knew each other's landscapes and the people who inhabited
them. Bewick's maternal grandfather was a schoolteacher in
Ainstable in the Eden Valley, that lush green triangle between
the Lakeland fells and the Pennines: his relatives still lived
there, and one cousin was a famous Cumbrian wrestler.
Inevitably, they noticed similar 'incidents of common life', like
the vagrants who travelled the north-country roads. Bewick's
tailpiece of an old beggar could almost be an illustration to
Wordsworth's 'The Old Cumberland Beggar', another poem
of 1798:

> I saw an aged Beggar in my walk;
> And he was seated, by the highway side,
> On a low structure of rude masonry
> Built at the foot of a huge hill, that they
> Who lead their horses down the steep rough road
> May thence remount at ease. The aged Man
> Had placed his staff across the broad smooth stone
> That overlays the pile; and, from a bag
> All white with flour, the dole of village dames,

He drew his scraps and fragments, one by one;
And scanned them with a fixed and serious look
Of idle computation . . .

Bewick's beggar, too, is seated on a pile of stones, and, as in a poem, he uses subsidiary details as images to endow the main scene with layers of suggestion. The peacock on the wall tells us that this is the 'beggar at the rich man's gate', a version of Dives and Lazarus, a text beloved by radicals, while his wooden leg and old coat suggest that he is an old soldier back from the wars. So who, if not the plutocrats and the government, Bewick asks, has turned him into a beggar? In a similar vein, Dorothy Wordsworth's journal notes that one October day 'A man called in a soldier's dress – he was thirty years old, of Cockermouth, had lost a leg and thigh in battle, was going to his home. He could earn more money in travelling with his ass than at home'.

In his autobiography Bewick wrote of the old soldiers he met on his walks, whose military coats ended up on scarecrows in the fields. He and Wordsworth had come across men like this all their lives, so that Wordsworth's beggar is almost an emblem, a still point linking past and present:

> Him from my childhood have I known; and then
> He was so old, he seems not older now;
> He travels on, a solitary Man . . .

Poet and engraver both returned obsessively to childhood scenes, and to the theme of the 'solitary man', endlessly travelling. There are deeper links between them than Wordsworth might have suspected, linked to their attitudes to art, politics, and, above all, to a poetic apprehension of man's relation to nature.

In the Preface, Wordsworth writes (in a passage that sounds enormously self-aggrandising, especially when read aloud):

> Taking up the subject, then, upon general grounds, let me ask, what is meant by the word Poet? What is a Poet? to whom does he address himself? and what language is to be expected from him? – He is a man speaking to men: a man, it is true, endowed with more lively sensibility, more enthusiasm and tenderness, who has a greater knowledge of human nature, and a more comprehensive soul, than are supposed to be common among mankind; a man pleased

with his own passions and volitions, and who rejoices more than other men in the spirit of life that is in him; delighting to contemplate similar volitions and passions as manifested in the goings-on of the Universe.

Does Bewick qualify? He had a lively sensibility, plenty of enthusiasm and tenderness, a shrewd knowledge of character and an abundant spirit of life, but he would have balked at the thought of possessing a 'comprehensive soul'. Far from seeing 'similar volitions and passions' in the universe, he felt rather the opposite – that the universe and the natural world were astounding in their variety and their *difference* to the ways and desires of men. In terms of his art, however, he was undoubtedly a 'man talking to men', using a 'common language'.

The medium of Bewick's art was wood-engraving, which he retrieved from its low status as cuts for newspaper headings and illustrations to chapbook romances, and made into an admired art. Bewick's great technical advances were achieved because rather than cutting on the plank, as earlier artists had done, he worked on the hard end-grain of boxwood, which allowed him to use the finer tools of the copper-engraver. Just as echoes of eighteenth-century formality linger in Wordsworth's work, so the rococo swirls and elegant compositions of the copper-engraver are found in Bewick's art, while 'polite' or 'picturesque' subjects like ruined arches often appear in a parodic form that makes a political or conceptual point, like the man desperate to shit who takes refuge behind

a ruined wall (no different to his pigs except in the thin veneer of 'civilised' modesty). In another version a woman passing by ostentatiously holds her nose.

As well as refining engraving, Bewick revolutionised his art by lowering the woodblock's surface in particular areas: this gave a softer tone when printed, providing a sense of distance and perspective and enabling him to introduce subsidiary motifs without distracting from his main subject. His 'common language of men' was an old popular art transformed into a new, more subtle mode, paralleling what Wordsworth and Coleridge were attempting with the old ballad form. His deft touch could convey the softness of plumage or the roughness of a drystone wall. If his tailpieces are like ballads, his finest vignettes, like the fox under the rock, where the animal springs forward against the darkness below the slabs of millstone grit and the central

image is framed in a rolling counter-movement of water and wind-blown foliage, resemble a lyric – possessing a condensed suggestiveness, a completeness, a musical movement.

Bewick's scenes, like Wordsworth's poetry, often hark back to the vanished childhood years. He was born in 1753 at Cherryburn, a few miles upriver from Newcastle, where his father farmed and ran a couple of small mines. Perched above the deep valley, the farmhouse gazed westwards to the fells across the fine pasturage of the common, divided by clumps of gorse, foxgloves, ferns and juniper, 'with hether in profusion sufficient to scent the Whole Air'. One Cherryburn vignette shows a small boy in petticoats, perhaps his brother John, on the verge of pulling a horse's tail. It is a perilous moment – the great horse rolls its eye and raises its hoof and the toddler's

Cherryburn, by John Bewick, 1781

mother belts over the stile in a panic to save her darling. But
Bewick adds a gloss in his receding distances: the blame lies
with the neglectful dairymaid, otherwise occupied in the
bushes. But if we look even further in, to the horses frolicking
in the far field, we may merely think that it is spring, and this is
'nature' after all.

Another childhood scene shows children building a snow-
man, above a motto *Esto perpetua*, 'Let it endure for ever'. This
is an obvious joke, as we know the snow sculpture will melt.
But local readers might recognise the motto as having been
recently engraved on a map of Newcastle, under the city's elab-
orate coat of arms. It derived from a famous cry of defiance
from Venice against the centralised power of the papacy, and its

translation to 'The Tyne against Westminster for aye' could raise a smile. But the final joke runs deeper. The boys will grow up, and their world will pass away: only art, even of this simple kind, can make this moment endure.

Cherryburn remained to Bewick as a kind of Eden. His auto-biography, published long after his death, rejoices in the wildness of his youth, his truant days spent in bird's-nesting, damming the streams, fishing, running over the fells. His memories describe an instinctive closeness to the natural world similar to Wordsworth's, as he looks back on his boyhood self bounding over the mountains, in 'Tintern Abbey':

> For nature then
> (The coarser pleasures of my boyish days,
> And their glad animal movements all gone by)
> To me was all in all. – I cannot paint
> What then I was. The sounding cataract
> Haunted me like a passion: the tall rock,
> The mountain, and the deep and gloomy wood,
> Their colours and their forms, were then to me
> An appetite; a feeling and a love,
> That had no need of a remoter charm,
> By thought supplied, nor any interest
> Unborrowed from the eye.

As a child Bewick's whole being was centred on the 'eye' – the difference being that he did reflect on what he saw, like the

ant-heap that he passed on the way to school. He drew with extraordinary ease from an early age and longed to work with pictures. But when the day came for him to be apprenticed in Newcastle, he could hardly bear it. 'I can only say my heart was like to break', he recalled:

and as we passed away – I inwardly bid farewell, to the whinney wilds – to Mickley Bank, the Stob Cross hill, to the water banks, the woods, & to particular trees, and even to the large hollow old Elm which had lain (perhaps) for centuries past, on the haugh near the ford we were about to pass & had sheltered the Salmon-fishers while at work there, from many a bitter blast ...

Where Wordsworth writes of 'colours and forms', 'rock', 'mountain' and 'wood', Bewick names the hills and picks out the *particular* elm, not as natural phenomena which will be

'endowed with a remoter charm' by the thoughtful adult watcher, but as part of the worked landscape of the river.

As an apprentice, working in the centre of a thriving port, Bewick had to learn every kind of task, from engraving bottle moulds and clock faces to crests on silver, and 'writing engravings of Bills, bank notes, Bills of parcels, shop bills & cards'. He made his name illustrating children's books and fables, and also plunged into the radical clubs of the town, supporting the rebels in the American War of Independence, fulminating against government corruption and against the Enclosure Acts that robbed country people of their rights. One of his more eccentric ideas – in keeping with his own fascination with incised inscriptions – was that poetry could literally be set in the landscape for the common people to read, as he showed in his vignette of the great rock inscribed with lines from 'The Deserted Village':

> Ill fares the land, to hastening ills a prey,
> Where wealth accumulates, and men decay.
> Princes and lords may flourish, or may fade;
> A breath can make them, as a breath has made:
> But a bold peasantry, their country's pride,
> When once destroy'd, can never be supplied.

His apprenticeship over, he travelled to Scotland, whose Highland communities remained in his mind as a kind of Rousseauian idyll, and then went to London, which he hated: 'It appeared to me to be a World of itself where everything in

the extreme might at once be seen – extreme riches – extreme poverty – extreme Grandeur & extreme wretchedness.' In later life he told his friend William Bulmer: 'I would rather be herding sheep on Mickley bank top than remain in London although for doing so, I was to be made Premier of England.' As he felt himself dwindling to nothing in London's 'great mass of moving humanity', his memories of Northumberland gave solace of the kind Wordsworth evokes in 'Tintern Abbey' where, he writes, memories of his native landscape

> Through a long absence, have not been to me
> As is a landscape to a blind man's eye:
> But oft, in lonely rooms, and 'mid the din
> Of towns and cities, I have owed to them
> In hours of weariness, sensations sweet,
> Felt in the blood, and felt along the heart.

The double exile, from childhood and from a particular place, often seems the essence of Romantic yearning; Bewick, like Wordsworth, possessed an inner 'eye' that could recapture them at will.

After his return to Newcastle, Bewick engraved his animals and birds by candlelight, in the evenings after work, turning his quick sketches into precise engravings. Many had stories attached, like those that amateur naturalists were just beginning to exchange in correspondence and in clubs. The foumart, the polecat, carries eels in his jaw because the people around Cherryburn had found mysterious curling tracks in the snow and when they dug out the polecat's den, they unearthed the remains of eleven eels. This was the first time the animal had been associated with them. But it is the formal qualities

THE FOUMART

that make this illustration a 'poem': the sinuous curve of pole-cat and eel against the bank of snow; the surrounding curve of the blasted tree and waving grass; the farm in the background.

George Atkinson, one of the founders of the Northumberland Natural History Society, remembered how 'the Idea of Socrates "that the summit of our knowledge is only to perceive our own ignorance"' was a great favourite with him:

> He had it (whence I know not) on a poetic form, thus –
>
> > What is discovered only serves to shew,
> > That nothing's known, to what is yet to know.
>
> He used to quote it with great emphasis and solemnity, and often added some such remark as 'Why sir, it would take a man a lifetime to write the history of a spider'.

I doubt Wordsworth would ever have thought like this. In 'Michael', although we see the old shepherd's life, the sheep remain hazy – rightly so, as this is a harrowing human story, not an agricultural tale – but nonetheless, Bewick would have made us see the exact breed. The detail and intensity of his gaze render him closer to Dorothy than to her brother. While Wordsworth's beggar gives his scraps to 'little mountain birds', Bewick would have identified finches, buntings, sparrows, just as Dorothy notes the 'Skobbys Robins Bullfinches' in the garden, or watches the young bullfinches bustle and pose in a May orchard, 'like Wire dancers or tumblers, shaking the twigs and dashing off the Blossoms'.

THE WILLOW WREN

Bewick often depicts birds in their settings, like the lovely Willow Wren by the stream. He does not consider humanity as necessarily superior in the great chain of being, but as only one species among many, and a destructive one at that, dangerous to the creatures of the wild and to ourselves, riven by dreams and ambitions, memories and regrets. In this he really does resemble Burns, at least in the famous lines to the field mouse, the 'Wee, sleekit, cow'rin, tim'rous beastie'. On turning up her nest with the plough, in November 1785, Burns notes wryly that the best-laid plans of mice and men both go awry:

> I'm truly sorry Man's dominion
> Has broken Nature's social union,

An' justifies that ill opinion,
Which makes thee startle,
At me, thy poor, earth-born companion,
An' fellow-mortal!

. . .

Still, thou art blest, compar'd wi' me!
The present only toucheth thee:
But Och! I backward cast my e'e,
On prospects drear!
An' forward, tho' I canna see,
I guess an' fear . . .

Bewick's attentiveness and feeling for animals and birds is closer, too, to John Clare than to Wordsworth. Clare's poems on birds and their nests pay the same loving attention to the shape and colour of the eggs, to the way they lie in the nest, to the plumage, stance and patterns of flight of the adult birds, like the skylark, whom the running schoolboys disturb:

Up from their hurry, see, the skylark flies,
And o'er her half formed nest, with happy wings
Winnows the air, till in the cloud she sings,
Then hangs a dust-spot in the sunny skies,
And drops, and drops, till in her nest she lies.

Clare's language – 'Winnows the air' – and his use of rhythm to mimic the sudden startling fall of the lark, is matched by Bewick's attention to the texture of fur and feather, the individual rhythm of movement or flight. His hare, for example, has the quickness and sudden nervous leaping of Clare's 'Hares at play', which describes how the hares play night-silvered fields, 'Like happy thoughts dance, squat and loiter still', but when the milkmaids' jingling yoke startles them, 'Through well-known beaten paths each nibbling hare / Sturts quick as fear, and seeks its hidden lair.' As a boy, Bewick explains in his memoir, he learned much from the local hunters who studied their

prey so carefully, and he went out with them as often as he could. The turning point came during a hare coursing when he caught the hare in his arms as the pack surrounded it and it 'screemed out so pitiously, like a child, that I would have given any thing to save its life'. He never hunted again.

THE ROOK

In *Land Birds*, the birds often appear against a background that shows their place in human lives, yet celebrates their freedom in their own element. Thus the rook stands against the farm landscape, while behind him the flock feed on the new wheat, nest in the rookery behind the old house and whirl in

flocks above the horizon. As George Atkinson noted, even on the tiny scale of the woodcuts, 'His power of giving each characteristic of animals, even at a distance, was extraordinary. It is exemplified in his distant flights of birds, which can always be recognized; and when he gives to them any cause of excitement they are highly entertaining.' As an example, he pointed to a scene of two cows drinking, 'above which we have most intelligibly depicted the futile attempts of a hawk to make his escape from the buffetings of two tyrannical crows; the magpies, like schoolboys, only being there to see the fun'.

Bewick imbued this unassuming scene with something beyond mere observation. It has a kind of sturdy power, a suggestion that these things relate in some untold way to our moral being. His understated detail charmed Tennyson, who adored Bewick's engravings as a child. Many years later, on the flyleaf

of a copy of the *History of British Birds* in Lord Ravenscroft's library, he pencilled these lines:

> A gate and field half ploughed,
> A solitary cow,
> A child with a broken slate,
> And a titmarsh in the bough.
> But where, alack, is Bewick
> To tell the meaning now?

The 'meaning' is elusive. But Bewick's philosophy – he was no churchgoer – was that life should be valued in its most insignificant forms. Knowledge, reason, philosophy and ethics begin with appreciation through the senses, what Wordsworth calls 'all the mighty world / Of *eye* and ear':

> both what they half create,
> And what perceive; well pleased to recognise
> In nature and the language of the sense,
> The anchor of my purest thoughts, the nurse,
> The guide, the guardian of my heart, and soul
> Of all my moral being.

Looking so closely at animals and birds makes the place of humanity seem small, and the power of imagination huge. In Wordsworth's words, 'We see into the life of things'. As Bewick described the move from writing about land birds to water birds he touched on his own sense of mystery. The migratory

birds in particular carry us to the wild lakes and empty tundra of the north, to dark seas raging against ice-covered rocks:

> There a barrier is put to further enquiry, beyond which the prying eye of man must not look, and there his imagination only must take the view, to supply the place of reality. In these forlorn regions of *unknowable* dreary space, this reservoir of frost and snow, where firm fields of ice, the accumulation of centuries of winters, glazed in Alpine heights above heights, surround the pole, and concentre the multiplied rigours of extreme cold; even here, so far as human intelligence has been able to penetrate, there appears to subsist an abundance of animals, in the air, and in the waters.

Recognising the melancholy yearning, as well as the folk-tale quality of the vignettes themselves, Charlotte Brontë gave this passage to Jane Eyre as a child, as she sits in the window seat, 'with ceaseless rain sweeping away wildly':

> I returned to my book – Bewick's History of British Birds . . . there were certain introductory pages that, child as I was, I could not pass quite as a blank. They were those which treat of the haunts of sea-fowl; of the 'solitary rocks and promontories by them only inhabited' . . . Each picture told a story; mysterious often to my yet undeveloped understanding and imperfect feelings, yet ever profoundly interesting: as interesting as the tales Bessie sometimes

narrated on winter evenings . . . with Bewick on my knee, I was then happy.

Bewick's vision of the water birds circling the pole shifts the place of man in relation to the universe. The sudden, awed, piercing delight in the abundant life that exists beyond the knowledge of man, recalls Coleridge's Ancient Mariner, feeling the burden of guilt slip from him as he watches the water-snakes:

> Beyond the shadow of the ship,
> I watched the water-snakes:
> They moved in tracks of shining white,
> And when they reared, the elfish light
> Fell off in hoary flakes.
>
> Within the shadow of the ship
> I watched their rich attire:
> Blue, glossy green, and velvet black,

They coiled and swam; and every track
Was a flash of golden fire.

O happy living things! no tongue
Their beauty might declare:
A spring of love gushed from my heart,
And I blessed them unaware.

Bewick was a man of the Enlightenment whose language belonged to the Romantic age. How, he asks in his *Autobiography*, could one accept the Mosaic story of 'the time that God took to make this World, with the whirling floating Universe of which it is comparatively as a small part, a speck – a mote'?

No, no, this sublime, this amazing, this mighty work of Suns & Worlds innumerable is too much for the vision, of a finite purblind proud *little* atom of the creation, strutting about in the shape of Man . . . the powers of the mind would soon become bewildered & lost, in attempting even to form any conception by figures of what is meant by *unnumberable* Millions of centuries – here on this subject we must rest!

Rather like the tiny figures in John Martin's paintings, human beings become insignificant specks in the flow of life. Like Bunyan's Christian and Wordsworth's Cumberland Beggar, each of us is a traveller, 'a solitary man', finding our path through life.

In walking – in a literal as well as metaphorical sense – Bewick experienced the intense closeness to nature on the grand scale that thrills us in Wordsworth's poetry. Every weekend of his apprenticeship and for many years afterwards, until the death of his parents in 1785, he walked up to Cherryburn each weekend, starting out after work, pacing on in all weathers:

> To be placed in the midst of a Wood in the night, in whirl-winds of snow, while the tempest howled above my head, was sublimity itself & drew forth aspirations to Omnipotence such as had not warmed my imagination so highly before – but indeed without being supported by extacies of this kind, the spirits, so beset, would have flagged & I should have sunk down.

The note he strikes here, and the quality he celebrates in his figures of animals and birds, and his vignettes of the fox against the rock, or the man struggling across the moor, is not that of 'The Two Thieves', but of 'Tintern Abbey'. In Bewick's art,

too, we sense the overwhelming energy of nature, the 'sense sublime / Of something far more deeply interfused',

> Whose dwelling is the light of setting suns,
> And the round ocean and the living air,
> And the blue sky, and in the mind of man;
> A motion and a spirit, that impels
> All thinking things, all objects of all thought,
> And rolls through all things.

Coda

'Some easy pleasant book'

For young children, the pictures are inseparable from the words. They know who Peter Rabbit is because Beatrix Potter has shown them, and – until Disney made new models for a new generation – the only 'real' Winnie the Pooh, or Mole and Ratty and Badger and Toad, were drawn by E. H. Shepard. Children born in the late twentieth century have no flicker of doubt about what Roald Dahl's BFG looks like: they have seen him, in Quentin Blake's illustrations.

Illustrators have been to the fore in publishing for children since the start of the eighteenth century. This stemmed partly from new ideas about how children learn, derived from writers like Locke, who felt that perception and association were profoundly linked to the senses, particularly sight, and to the search for pleasure. 'And how covetous the mind is to be furnished with all such ideas as have no pain accompanying them', he wrote in *An Essay Concerning Human Understanding* in 1690, 'may be a little guessed by what is observable in children new-born; who always turn their eyes to that part from whence the light comes, lay them how you

please.' The eye is the key: and illustrations shed light, as their name implies. Locke developed his idea in *Some Thoughts Concerning Education* in 1693. When a boy begins to read (it is always a boy), 'some easy pleasant book' should be given to him, 'wherein the entertainment that he finds might draw him on, and reward his pains in reading'. *Aesop's Fables* would do best, Locke decided, and:

> If his Aesop has pictures in it, it will entertain him much the better, and encourage him to read, when it carries the increase of knowledge with it: for such visible objects children hear talked of in vain and without any satisfaction whilst they have no ideas of them; those ideas being not to be had from sounds, but from the things themselves or their pictures. And therefore I think as soon as he begins to spell, as many pictures of animals should be got him as can be found, with the printed names to them, which at the same time will invite him to read, and afford him matter of enquiry and knowledge.

Following Locke's advice, works like A *Little Book for Children* (1712) used pictures to teach letters and words. A publishing boom began, and parents of moderate income could buy beautifully decorated little books, produced in a perfect size to fit a child's hand. There were songbooks and rhymes, collections of animals, alphabets with lively, comical images, as well as illustrated editions of Aesop, abridgements of popular favourites like *Gulliver's Travels* and *The Pilgrim's*

Progress, and translations of fairy tales such as 'Cinderella', 'Sleeping Beauty' and 'Puss in Boots'. All were illustrated with woodcuts, like Thomas Bewick's youthful Red Riding Hood at the start of this chapter. Ever since, children's book-writers have hunted out good illustrators. Some of the most memorable illustrations, of course, are by the authors themselves. A special case is Edward Lear, who already had a reputation as a fine artist, especially for his watercolours of Greece. But he revealed a new, bizarre talent in the scratchy drawings for his *Nonsense Songs*, of the Owl and the Pussycat, the Jumblies in their sieve, and the Two Old Bachelors climbing the crag in a muddled hunt for sage and onion stuffing:

> And at the top, among the rocks, all seated in a nook,
> They saw that Sage, a-reading of a most enormous book.

'You earnest Sage!' aloud they cried, 'your book you've
 read enough in! –
We wish to chop you into bits to mix you into Stuffin'!'

Many illustrators have felt rather like the Bachelors, bashed on
the head by the Sage's 'awful book'. With famous partnerships,
even when the pictures seem effortlessly wedded to the text,
the 'easy pleasant book' may hide battles behind the scenes.
C. L. Dodgson, 'Lewis Carroll', began writing a 'fairy tale for
Alice' in November 1862. When he decided to publish it he
chose John Tenniel, whom he admired for his illustrations for
Aesop's Fables and his cartoons for *Punch*. He knew that
Tenniel's fame would sell the book, and indeed at first it was
the illustrations that caught the reviewers' attention. These
were based, however, on Carroll's own precise vision of every
character, setting and scene. He had sketched many of these
himself in the manuscript of *Alice's Adventures Underground*,
the original 'fairy tale' for Alice Liddell. Tenniel built on them
closely: Bill the Lizard leaping from the chimney, Alice falling
into the pool of tears, her baffling encounters with the pack of
cards, and the terrifying view of her slowly outgrowing the
room. Other designs were discussed between them, and, once
drawn, Carroll checked almost every line so pedantically that
later Tenniel dismissed him as 'that conceited old Don'. On his
side, Tenniel was slow and made his own demands. Sometimes
he won, keeping a drawing despite Carroll's objections, and
even persuading the author to change the words. When he

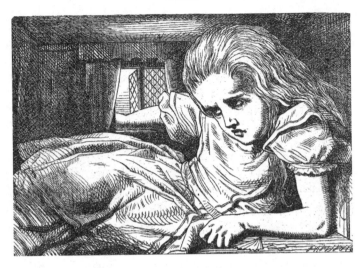

objected to the bad printing in 1865 (his drawings were engraved on wood by the brothers Edward and George Dalziel, and the printing was done from electrotypes – electro-plated moulds – of their woodblocks), almost the whole first edition was shipped to America and the book was reprinted for the British market.

Tenniel at first refused to illustrate the sequel, changing his mind only after Carroll failed to agree with anyone else. But it was the last time. 'With Through the Looking-Glass,' he said, 'the faculty of making drawings for book illustrations departed from me . . . I have done nothing in that direction since.' In 1889 he warned the Irish artist Harry Furniss, who was about to illustrate Carroll's *Sylvie and Bruno*, that 'Lewis Carroll is

impossible'. Yet despite the author's bullying, Tenniel's brilliance shines through: in the White Queen and her fierce Red opposite, in the grinning Cheshire Cat, the White Rabbit and the Dormouse, the Walrus and the Carpenter, Humpty Dumpty and in every added detail, from teacups to kittens. As Michael Hancher has shown in his book on these drawings, Tenniel, like other fine illustrators, played with 'high art'. His Duchess ('Speak roughly to your little boy / And beat him when he sneezes / He only does it to annoy, / Because he knows it teases') is a descendant of Quinten Massy's sixteenth-century *Grotesque Old Woman*, while 'Alice in the railway carriage' manages to squeeze a caricature of Disraeli into a composition that blends Augustus Egg's *The Travelling Companions* with the docile, apprehensive-looking little girl in Millais's *My First Sermon*.

In his play with images, Tenniel also borrowed from the *Punch* stable: Tweedledum and Tweedledee are versions of his own John Bull; the caterpillar with his hookah resembles John Leech's cartoon of the Pope as an oriental potentate; his brilliant Jabberwock adapts a frightening du Maurier cartoon, 'A Little Christmas Dream', itself the heir to Salvator Rosa's monster in the *Temptation of St Anthony*. Tenniel's 'Jabberwock and the young knight', originally intended as a frontispiece to *Through the Looking Glass*, was moved inside the book after Carroll showed it to several mothers, who confirmed his view that it was 'too terrible a monster, and likely to alarm nervous and imaginative children'.

Perhaps because of the stress her creator was inducing, Tenniel makes us *feel* Alice under pressure, shrinking and growing. In later life Tenniel sported a wispy walrus moustache which made him look rather like the hapless White Knight: a coincidence which is all the odder because the Knight, as Tenniel knew, was often taken to be a caricature of Carroll himself. Carroll had greatly objected to the Knight's facial hair: 'The White Knight must not have whiskers,' he insisted, 'he must not be made to be old.' It is as if illustrator and author, always at odds, were almost too close for comfort.

The frontispiece for *Through the Looking Glass* that replaced the scary Jabberwock, illustrates the scene where the Knight leaves Alice. It returns us once again to the solitary man, the pilgrim, the beggar, the artist, aiming at dreams, setting out on a quest full of perils and hopes. He asks if she will wave her handkerchief when he gets to the turn in the road:

'I think it'll encourage me you see.'

'Of course I'll wait,' said Alice, 'and thank you very much for coming so far – and for the song – I liked it very much.'

'I hope so,' the Knight said doubtfully, 'but you didn't cry so much as I thought you would.'

So they shook hands, and then the Knight rode slowly away into the forest.

*

If children accept that the pictures are the book – as Charles Lamb felt about the woodcuts in *The Pilgrim's Progress* – the

opposite can apply to older readers, to whom illustrations can be infuriating, especially in novels. We have our own image of Becky Sharp in *Vanity Fair* – the picture is clearly 'wrong', even if sketched by Thackeray himself. Not surprisingly, many writers have felt uncomfortable at having their work illustrated. After working with Frederic Leighton on *Romola* in 1863, George Eliot wrote to him sadly of 'the inevitable difficulty, nay, impossibility of producing perfect correspondence between my intention and the illustrations'. The critic J. Hillis Miller, in his highly theoretical book *Illustration*, quotes Henry James's comment, in the preface to *The Golden Bowl*, on the photographic frontispieces to the New York edition of his novels: 'I, for one, should have looked askance at the proposal, on the part of my associates in the whole business, to graft or "grow", at whatever point, a picture by another hand on my own picture – this being always, to my sense, a lawless incident.'

James's organic image of 'grafting', turning a root-stock into a quite different tree, is a sombre statement of authorial unease. He was reacting against the popular tradition of the previous century, where almost all new novels had illustrations. He knew their power, admitting, in *A Small Boy and Others*, that when he was a child, *Oliver Twist* meant Cruikshank's engravings, not Dickens's words. The artist would have agreed: in his later years Cruikshank claimed that he had 'written' *Oliver Twist*, providing the pictures to which Dickens wrote the text when it appeared in monthly issues in *Bentley's Miscellany* in 1837, and, in particular, had invented the character of Fagin.

Dickens, who always remained friendly with Cruikshank, merely replied that he had long thought him 'quite mad'. Cruikshank is one of our great neglected British geniuses, and I am not surprised that Quentin Blake nominated him for BBC Radio 4's *Great Lives* in 2007. But while he and Dickens sparked ideas off each other, his stubborn independence meant that he would never willingly be seen as subordinate. Dickens, on the other hand, wanted control: they never worked together again.

In her book on Dickens's original illustrators, Jane Cohen quotes van Gogh – an unlikely fan – who declared that 'There is no writer, in my opinion, who is so much a painter and black-and-white artist as Dickens'. He was soaked in the world of prints, a great admirer of Hogarth, Rowlandson and Gillray: *Oliver Twist*'s subtitle 'A Parish Boy's Progress' reminds us at once of Hogarth, and of Bunyan. He once told John Forster that he didn't 'invent' his stories, 'really do not, but *see* it and write it down', and he clearly wanted them to be *seen* in this way, just as they had taken shape in his imagination. To do that, he felt he needed to specify the scene, the number and position of the characters, their dress, gestures, even the furniture in the background. As Carroll would later do with Tenniel, he looked over the drawings, made changes and fussed over each stage of the proofs. Far from the pictures coming between author and reader, in Dickens's case they really are a clue to his vision.

There were nearly nine hundred original illustrations to Dickens's work over the years. All the novels, except *Hard*

George Cruikshank, 'Oliver Asks for More', *Oliver Twist*, 1837–9

Times and *Great Expectations*, were illustrated on first publication, most appearing first in monthly or weekly journals, with one or two engravings for each episode. From the start, with *Pickwick Papers* in 1836, Dickens's success with illustration was such that publishers rushed to follow his example. But ironically, the genesis of *Pickwick* lay in a project where the author was supposed to follow the illustrator, not the other way round: the artist Robert Seymour had suggested a series of scenes of sporting life and cockney wit, and the publishers Chapman and Hall set out to find an author. After several writers declined, they asked the twenty-four-year-old Dickens, who immediately turned the whole scheme on its head, insisting the text come first. And when the depressive Seymour committed suicide and his replacement, Robert Buss, proved inadequate, Dickens turned to a twenty-one-year-old engraver, Charles Hablot Browne, who signed his works first as N.E.M.O., 'no one' (a strange anticipation of the copywriter in *Bleak House*) and then – to match Dickens's 'Boz' – simply as 'Phiz'.

Phiz's descendant, Valerie Browne Lester, writes vividly of their collaboration in her biography of the artist, noting how Dickens wrote his comments straight on the design. On 'Mr Winkle's Situation when the Door "Blew To"', for example, he scribbled, 'Winkle should be holding the Candlestick above his head I think. It looks more comical the light having gone out . . . A *fat* chairman so short as our friend here, never drew breath in Bath. I would leave him where he is, decidedly. Is the lady full dressed? She ought to be.' Along the side of the sketch

'Mr Winkle's Situation when the Door "Blew To"', *Pickwick Papers*, 1836–7

Phiz posed his own questions: 'Shall I leave Pickwick where he is or put him under the bed-clothes? I can't carry him so high as the second floor.' Even facial expressions drew Dickens's scrutiny, like Serjeant Stubbin, whom he thought 'should look younger and a great deal more sly and knowing; He should be looking at Pickwick too, smiling compassionately, at his innocence'.

Dickens was already dealing with Cruikshank on *Oliver Twist*, but the following year he and Phiz set off together for Yorkshire, seeking out models for Dotheboys Hall for *Nicholas Nickleby*. They would work together for over twenty years (although Phiz also drew for other writers, including Trollope and the Irish novelist James Lever). He illustrated ten Dickens novels, including *David Copperfield*, *Dombey and Son*, *Martin Chuzzlewit*, *Bleak House* and *Little Dorrit*, creating the outward and visible shape of such characters as Pickwick and Sam Weller, Squeers and Smike, Little Nell, Mr Micawber and Betsey Trotwood, Mr Guppy and Jo the Crossing Sweeper, and Mrs Gamp. His art, as Michael Steig has noted in *Dickens and Phiz*, adapted itself to Dickens's writing: both became more serious and realistic as the years went by. But in the later novels the detail and imagery of Dickens's descriptions almost annihilated any chance of faithful illustration, and under this pressure, and his own desire to find new forms, Phiz experimented with the atmospheric 'dark plates' of *Bleak House*, drawing howls from the critics and many jokes about the artist's 'Black Art'. *Little Dorrit* followed, with the usual

'Restoration of Mutual Confidence between Mr and Mrs Micawber',
David Copperfield, 1850

peremptory notes: 'Mrs Plornish is too old, and Cavaletto a
leetle bit too furious and wanting in stealthiness.' But although
Phiz dealt brilliantly with the comic elements and the rickety
villainy of characters like Flintwich, the toppling gloom of the
novel, and its immense detail, seemed to overwhelm him, just
as Little Dorrit herself shrinks beneath the great prison arch of
the Marshalsea.

It was time to part. Dickens needed a new style, and Phiz
had already made a bid for freedom by working for *Once a
Week*, a rival to Dickens's *Household Words*. Their last work

'Mr Flintwich has a Mild Attack of Irritability', *Little Dorrit*, 1855–7

together was *A Tale of Two Cities* in 1859. Searching for a reason for their break, Phiz suggested that Dickens was disconcerted by the staging of Watts Phillips's play, *The Dead Heart*, which had almost the same plot as his novel. 'All this put Dickens out of temper,' wrote Phiz, 'and he squabbled with me among others, and I never drew another line for him.' It is more likely, however, that both writer and artist were simply exhausted. For his final books – *Great Expectations*, *Our Mutual Friend* and *The Mystery of Edwin Drood* – Dickens turned to younger artists, Marcus Stone and Luke Fildes, neither of whom was even born when he and Phiz began to work together. Unlike Tenniel, Phiz still worked for other writers, until illness stopped him, but he confessed he was 'a-weary of this illustrating business'. The last print he engraved for Dickens in *A Tale of Two Cities* was of the old, tired, hunched figure of Dr Manette, alone in his cell in the Bastille, enormous chains hanging from the walls. The 'easy, pleasant' books that we enjoy have often been hard to create.

It came as a shock, reaching the end of this book, to find myself writing about a man in his cell, cut off from the world, taking me back to Milton in his blindness and Bunyan in his Bedford prison. Because what I have been discovering is quite the opposite of solitary confinement. The response of artists to writers is an act of communication and creation – however fraught or full of misunderstandings their dialogue, spoken or unspoken, may be. Just as writing moves out towards unknown

Dr Manette, *A Tale of Two Cities*, 1859

readers, away from the lonely craft of imagining, composing, putting the words on paper, and just as drama is ever-changing, brought to life by different actors and directed to new audiences, so illustrations, paintings and drawings inspired by literary works look outwards from the text that is their starting point, transposing verbal to visual. Sometimes they literally illustrate – shed light on – the words; sometimes, as with Hogarth prints, they have their own separate trajectory; sometimes, like the oxen in the Luttrell Psalter, they may introduce a new, tangential line of thought altogether. They have their own idiom and conventions, born of their own period, like the chapbook illustrations to Bunyan, and their own vision and style, the signature of the individual artist.

I have not been writing about influence or parallels, but about contacts and collaborations, about the elusive, unexamined crossings between different forms of expression, sometimes jostling for dominance. Such contacts cut across class, across the divide between the academic and the popular, and, as with the Milton and Bunyan illustrations, across time, creating their own lineage, a series of echoing images. Yet however closely writer and artist work together, their work can never 'mean' the same, because meaning is bound up with the writers' system of alphabetic symbols and words, and the artists' lines, shading and colours. In that sense they are always bound to be at odds. The image created by the words inhabits the picture, but the picture is both less and far more than a graphic equivalent of the words. It does not merely reflect, but

brings something of its own, in a separate act of creation. We may begin by seeing the pictures as the secondary form, but they can take on independent lives – like Hogarth's painting of *Satan, Sin and Death* – achieving a 'primary' status, detached from their source.

Each in their different way, and in dialogue with each other, words and pictures are gateways to imagining. They let us enter and see invented worlds, whether our guide be Bunyan's narrator or Bewick's labourer sleeping under a hedge after a boozy Whitsun holiday. In their uncertain conjunctions, pictures and words create that 'certain place' where we rest in the wilderness of the world and say, 'I dreamed a dream'.

Brief Further Reading

GENERAL

The critical and theoretical tradition runs from Plato, Plutarch and Horace's *ut picture poesis* ('as is painting, so is poetry'), to Renaissance humanists and on to Locke, Lessing's *Laocoon*, Ruskin, Saussure and semiotics. Influential twentieth-century theorists include Walter Benjamin, Barthes, Clement Greenberg and W. J. T. Mitchell in *Iconology*, 1986, and *Picture Theory*, 1994. For an impression of the scope of current academic studies, see the wide-ranging contributions to the quarterly *Word & Image*.

On book illustration a good general survey is still:
Jonathan Harthan, *The History of the Illustrated Book: The Western Tradition*, 1981, revised edition 1997

MILTON AND BUNYAN

Marcia Pointon, *Milton and English Art*, 1970
Stephen C. Behrendt, *The Moment of Explosion: Blake and the Illustration of Milton*, 1983
Gerda S. Nordvig, *Dark Figures in the Desired Country: Blake's Illustrations to The Pilgrim's Progress*, 1993
Robert Woof, Howard J. M. Hanley and Stephen Hebron, *Paradise Lost: the Poem and Its Illustrators*, exhibition catalogue for The Wordsworth Trust, 2004

HOGARTH AND FIELDING

Ronald Paulson, *Hogarth's Complete Graphic Works*, third revised edition, 1989

Mark Hallet, *Hogarth*, 2000

Henry Fielding: for authoritative texts of the drama, journalism and legal writings, see the *Wesleyan Edition of the Works of Henry Fielding*, ed. W. B. Coley, 1967–2008

WORDSWORTH AND BEWICK

George Atkinson, 'Sketch of the Life and Times of the Late Thomas Bewick', *Natural History Society of Northumberland Transactions* I, 1831

A Memoir of Thomas Bewick, written by himself, ed. Iain Bain, 1975

The Watercolours and Drawings of Thomas Bewick and His Workshop Apprentices, Iain Bain, 2 vols, 1981

CODA: 'SOME EASY PLEASANT BOOK'

Michael Steig, *Dickens and Phiz*, 1978

Jane Cohen, *Charles Dickens and His Original Illustrators*, 1980

Michael Hancher, *The Tenniel Illustrations to the 'Alice' Books*, 1985

Valerie Lester, *Phiz: The Man Who Drew Dickens*, 2005

A NOTE ON THE TEXT: quotations are presented in the form they appear in the source, hence the variation in use of capitals.

Acknowledgments

I began thinking about Wordsworth and Bewick for a Wordsworth Trust weekend in January 2007, and I would like to thank the Trust for this opportunity and for their generosity with regard to illustrations. The wider ideas were developed in the Northcliffe Lectures in Literature, University College, London, in February 2008, and in this connection I am grateful to Professors Rachel Bowlby and Rosemary Ashton, and to Kathryn Metzenthin.

My thanks also go to the institutions and individuals acknowledged in the List of Illustrations, and especially to Sheila O'Connell of the British Museum Department of Prints and Drawings, to Nigel Tattersfield and Iain Bain for assistance with Bewick wood-engravings, and to Valerie Browne Lester for material on Phiz. Less formally, I would also like to thank John Barnard, Norma Clarke, Mary Evans, Nina Miall, Timothy Mowl and Deborah Rogers for interesting conversations and useful leads.

The Faber team have been wonderfully supportive, as always: Julian Loose prompted me to write, Kate Murray Browne dealt patiently with detail, Neil Titman copy-edited, Trish Stableford proof-read, Diana LeCore indexed, Ron Costley gave advice on design and Kate Ward produced the final book with consummate skill. Throughout all the thinking and writing, I have been encouraged by the enthusiasm of my friend Hermione Lee, and have relied hugely on the support, help and IT know-how of my husband Steve. I thank them both.

List of Illustrations

2 Hogarth and Fielding: *Modern Moral Drama*

PICTURE CREDITS

I am grateful to the following for permission to reproduce illustrative material.

COLOUR PLATES: Coram in the care of the Foundling Museum, London/ The Bridgeman Art Library 10; The Huntington Art Collection, San Marino, California 2; Museum of Fine Arts, Boston 3; Museum of Fine Arts, Boston/ The Bridgeman Art Library Nationality 4; National Gallery, London, UK/ The Bridgeman Art Library, 11; Natural History Society of Northumbria 12, 13, 14, 15; Private Collection 5, 6; Private Collection/ The Bridgeman Art Library 8; Tate, London, 2008 1, 9; The Wordsworth Trust, Grasmere 16; Yale Centre for British Art, Paul Mellon Collection, USA/The Bridgeman Art Library Nationality 7.

ILLUSTRATIONS IN THE TEXT: Ashmolean Museum, Oxford 43; The Bridgeman Art Library 33; The British Library 4; The British Museum 38; The Estate of Edward Ardizzone 162; Iain Bain 37; Natural History Society of Northumbria 85b; Private collection 40; Sebastian Peake 6; The Wordsworth Trust, Grasmere 38.

All efforts have been made to trace copyright holders, but the author and publisher would be grateful for information if any have been overlooked.

Index

Figures in italics indicate illustrations.